To John Mendenhall, in friendship.

Acknowledgments: Special thanks to Audrey Tawa and Jeffrey Burbank for their wit, wisdom, and craftsmanship in preparing the text and in helping with other aspects of this book. Many thanks to Paul Chamberlain for his time and expertise shooting the numerous set-ups. Thanks to Bill LeBlond and Michael Carabetta at Chronicle Books for their direction and support; and also to Carey Charlesworth for her professional and thorough job of editing my manuscript. The following individuals have also generously helped me with information or have lent or given me packaging: David Baca, Art Chippendale, Dharam Damama, Michael and Nancy Domini, John and Edith Jankowski, Aaron Kraemer, Tom Lichtenheld, Evy J. Rudolph, Garry Tosti, and Jeanne Segal.

Library of Congress Cataloging-in-Publication Data

Jankowski, Jerry
 Shelf life: modern package design, 1920–1945 / Jerry Jankowski
 ; Paul Chamberlain, photography.
 p. cm.
 Includes bibliographical references.
 ISBN 0-8118-0075-X (pbk.)
 1. Packaging —History. 2. Packaging—Pictorial works. I. Title
HF5770.J36 1992
688.8—dc20 91–48065
 CIP

Editing: Carey Charlesworth
Text, book and cover design: Jerry Jankowski
Service bureau: fontographics
Fonts: Futura Medium Condensed, Industria, and Insignia

Printed in Hong Kong.

Distributed in Canada by Raincoast Books, 112 East Third Ave., Vancouver, B.C. V5T 1C8

10 9 8 7 6 5 4 3 2 1

Chronicle Books
275 Fifth Street
San Francisco, CA 94103

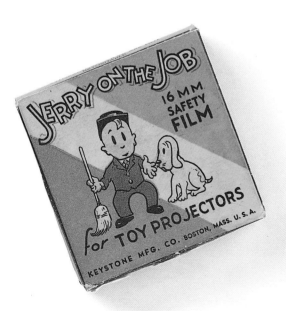

SHELF LIFE

MODERN PACKAGE DESIGN 1920-1945

JERRY JANKOWSKI

PAUL CHAMBERLAIN
PHOTOGRAPHY

CHRONICLE BOOKS SAN FRANCISCO

TABLE OF CONTENTS

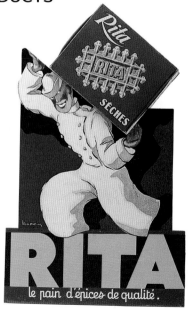

INTRODUCTION

Today, they sit by the thousands—shoulder to shoulder, row upon endless row, each one vying for a shopper's attention, if only for a precious, calculated second or two. They crowd the shelves of every retail store in every nation. From a modest Piggly Wiggly in Green Bay, Wisconsin, to the grand aisles of Au Bon Marché in Paris, little "silent salesmen" are at work around the clock, around the world. Their motto: to contain, to protect, to identify, to sell. And in a relatively short time-span they have quietly revolutionized all aspects of merchandising. "They" are the entire spectrum of tins, cartons, boxes, bottles, labels, and bags that exemplify the collective and truly modern term "packaging." ▣ From a designer's perspective, packaging reached its creative zenith during what is now called the Machine Age. Between the two world wars sprang up a bold and clean approach to packaging mass consumables, and the distinctive styles forged during these dynamic decades have proved their mettle, since many either still survive today or have lent their spirit to 1990s packaging. An examination of packaging history can help us appreciate why the "modern" look has made such an indelible mark on contemporary graphic design. ▣ The very concept of packaging, of course, has been used ever since humans became hunter-gatherers. In prehistoric times, they used natural materials to fabricate objects to contain, protect, and transport foodstuffs, medicines, clothing, ornaments, and other items. The "shoppers" of the day used hollow gourds, tree bark, and animal bladders in lieu of the milk carton, the paper bag, and cellophane. Naturally, as civilization advanced, so did packaging. ▣ When paper became cheaper and more available throughout Europe in the 1400s, it adapted itself to more everyday purposes. Paper labels for baled cloth from the 1500s are the earliest known form of printed label. Although labels may certainly have existed before this time (to identify the elixirs of alchemists and apothecaries), they probably would have been handwritten. ▣ In Germany during the late Renaissance, a papermaker named Andreas Bernhart began packing his product in a wrapper with a block-printed design. Bernhart printed a spirited woodcut of a horse, a shield, his name, and his shop's location—an early attempt at connecting the package, in this case a simple wrapper, with the product. It is also quite possible that the designs were cut out and used as labels by themselves. ▣ In 17th-century London, the volatile nature of the publishing industry unexpectedly helped increase the availability of paper. During this time, books were stocked in sheet form, unfolded and unbound until a buyer came along to purchase a tome like *The Compleat Angler*, Izaak Walton's best-seller of 1653. Books that were not purchased were sold as wrapping paper to the merchants. ▣ Before the 1880s, the use of paper wrappers and sealed envelopes was a common part of the city dweller's shopping experience. Frequently printed with a royal coat of arms, these "pacquets" were used to package a variety of goods including quack medicines, tobacco, playing cards, tea, pins, and wig powder. Beer was sold in handblown glass bottles. Ceramic pots were the conveyances of choice for snuff, prepared mustard, ointments, and pills. ▣ Though the use of packaging slowly gained momentum, it was far from taken for granted by either consumer or shopkeeper. An advertisement from a tea merchant in a 1680 London newspaper accurately

spells out the general scarcity of 17th-century packaging. Its caveat: "Bring a convenient Box." 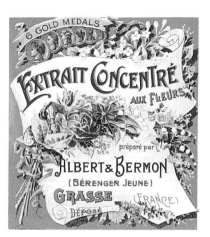 The art of typography and the technology of printing and papermaking were growing up together like siblings in friendly rivalry. The development of one pushed the advance of the other. Engraved copper intaglio plates, used in France and Italy as far back as the 1400s to reproduce fine art, became the medium for printing most labels in 18th-century England. The type styles designed by John Baskerville and by his contemporary William Caslon endure at the end of the 20th century as a standard of elegant legibility. ▪ The year 1798 saw two far-reaching accomplishments. The first was the invention of a machine for producing a continuous "web" of paper, created by the Frenchman Nicolas-Louis Robert. It was further developed in England with the financial backing of the Fourdrinier brothers. The second was the discovery by Alois Senefelder in Bavaria of the principle of stone lithography. This revolutionary method of printing could reproduce in mass quantities multicolored designs in subtle, graduated tones. Further developments (like the use of iron-framed presses that replaced those of wood) increased the speed and quality of production and helped bring costs down. London alone boasted seven hundred lithographers in 1854. ▪ Chromolithography, the printing from stones of up to twelve different colors by using dots and solid areas, was fully developed by the 1850s and came to dominate other methods of color printing in the mass market. And in the early decades of the 20th century it was in turn replaced by metal plate lithography, flatbed, and rotogravure printing processes. ▪ Thanks to chromolithography, and later the more advanced processes, the production of high-quality color labels became progressively more economical. These new, beautifully detailed

The two French labels exemplify the rich colors and meticulous rendering characteristic of late 19th century chromolithography. The one used for Extrait Concentré aux Fleurs by Albert and Bermon lends an air of prestige to its package by displaying a string of medals garnered from trade exhibitions. The undulating tendrils and fluid line of the letterforms on Jean Giraud Fils' Eau de Cologne Ambrée label epitomize the Art Nouveau style.

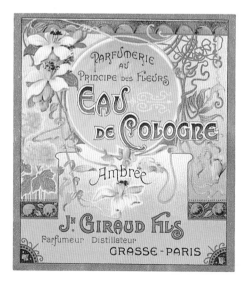

Exotic India is the theme of the Casanova cigarette tin printed in France around 1880. It is a beautiful example of offset lithography, a revolutionary process for its time.

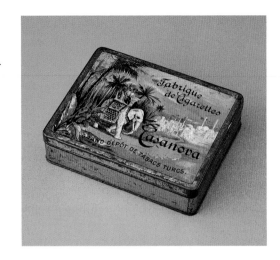

Rainbow coffee, a product of Pure Gold Manufacturing Company of Toronto, Canada, uses crudely stenciled type over an airbrushed background, c. 1860. Coffee and tea were among the first goods to be packaged in metal containers.

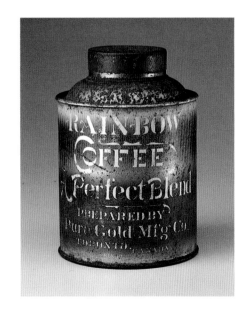

labels added sales appeal to tins and boxes as well as to the bottles and jars on which they were pasted. Luxury items that carried a higher sales value were especially targeted for the lithographer's craft. Boxes of fine toilet soap and bottles of rose water, perfume, and cognac, as well as jars of bear's marrow pomade—the in-vogue grooming aid—received label designs that today seem quintessentially Victorian in their decorative exuberance. ▪ The label illustrators and typographers of the second half of the 19th century had a conspicuous love affair with ornate framings of mind-boggling complexity. Multiple borders of curlicues, floral patterns, and Greek fretting were used without restraint. The labels' overall clutter and fussiness, regardless of product content, were trademarks of the time. ▪ A particularly notorious feature of Victorian design was its use of conflicting type styles to intensify the effect of ornamentation—the bane of Modernists in the following century. Delicate typefaces were contrasted with two new typographical styles confusingly named Grotesque, a sans-serif font inspired by Greek inscriptions, and Egyptian, a squat, square-serifed face. Multifarious derivations of these type styles were used and abused for the sake of novelty. ▪ Illustrated themes of the times tended toward either the pretty or the pompous. "Pretty" meant scenes of women and children in vignettes of upper-class daily life, varied flora and fauna, and a surplus of pudgy cherubs. For "pompous" there were always the tried-and-true coat of arms, the graphic depiction of medallions awarded for product excellence, and the endless portraits, of kings, queens, statesmen, and company founders. ▪ Paper, as it turned out, would serve a more functional purpose than just the medium for printed labels: it would serve as a means to contain them as well. As simple as the concept of

the paper bag may seem, it wasn't available to grocers until the mid-19th century. And it wasn't until the 1870s that the square-bottomed bag, the one still in use today, and a machine for its production, had commercial viability. Paper bags were instrumental in speeding up sales by eliminating the time it took to wrap items in paper and twine. The newly emerging department stores were also introducing an element of advertising to their bags by imprinting them with the store's name. At the end of the 20th century, the paper bag is still one of the most convenient and economical forms of packaging around.

Paperboard, less accurately referred to as cardboard, has been used to construct boxes from at least the first quarter of the 19th century. Boxes made during that period required a great deal of hand-cutting and gluing, and were used only for luxury or novelty items. The oldest existing paperboard box—which once contained a "Game of Besieging"—was made at that time in Germany. A problem arose, however, with the growing success of the paperboard box—its storage. The rigid "set-up" box, when not in service, was a great space waster since it could not be collapsed. Individually, the set-up box presents a minor problem, but the large quantities that manufacturers came to use in the 19th century created great warehousing demands. What was needed was a collapsible box that could be cheaply made. In 1879 the American Robert Gair constructed the first multiple die that would cut and crease paperboard in a single operation. The machine-made folding carton was born. Gair quickly adapted a secondhand press to cut and crease seven hundred and fifty sheets an hour, ten cartons to the sheet.

By 1897 eight hundred patents had been filed for ingenious carton structures, clever locking tabs, and machinery that made them. Of the many products packaged in folding cartons at the turn of the century, one, a soda cracker, is particularly famous. Its renown comes from its early advertising campaigns that relied as much on packaging and brand-name recognition to stimulate sales as on the merits of the product. When a representative of the National Biscuit Company (Nabisco) in New York told Robert Gair of its plans for a nationally advertised product, his son commented, "You need a name." Thus the cracker-barrel era in American shopkeeping ended with the name Uneeda and its folding carton. Thomas Huntley, a baker in Reading, England, had a different packaging problem to solve in the early 1830s. His dilemma was that the biscuits he was selling at the Crown Inn Coach Stop were so well liked that travelers were writing for more once they reached their destinations. He solved the problem of keeping his baked goods fresh and intact by having his brother Joseph, a tinsmith by lucky coincidence, make him the sturdy airtight tins that were needed. Thomas and Joseph Huntley were later to become the founders of two companies, the biscuit manufacturers Huntley and Palmers and also Huntley Boorne and Stevens, tin manufacturers. Both still do business in Reading. Huntley Boorne and Stevens' finely detailed tins were progressive for the time, and gave early impetus in Europe to the idea of attracting buyers to the package, not just to the product within. Huntley and Palmers, along with the equally inventive French bakers of Lefevre-Utile, marketed dozens of different biscuit tins, ranging in shape from grandfather clocks to windmills. Eagerly sought after today by collectors of Victoriana, many of these eccentrically shaped tins have

price tags of several hundred dollars. ■ The "tin" in a tin can is actually tinplate, a coating over steel. Tin cans and boxes have an enormous range of shapes and sizes—anywhere from a tiny one-sixteenth-ounce ointment container to a fifty-five-gallon barrel, and each can have dozens of styles of openings. The advantage of tin over other container materials, such as glass, lies in its unbreakable strength, its ready adaptability to high-speed automatic handling, its light weight, and its ability to stack and ship well. ■ The most common form of decoration on the early metal boxes, other than direct embossing, was still the paper label. Direct printing on tinplate was not very successful because the printing surface is not absorbent like paper. Hard metal type and lithographic limestone were not good matches with tinplate. ■ Much experimenting was conducted at the time, as evidenced by the many tin-printing patents then filed in France, Britain, and the United States. There were patents for improvements on new lead-based inks, coatings for the tinplate to use prior to printing, and methods for stenciling and transfer-printing. ■ Toward the last quarter of the century, the breakthrough "secret" of offset lithography was discovered by Robert Barclay. The process was rather nicely described in a trade journal at the time: "The impression is at first made from the stone onto a rubber roller and from this roller the ink is rolled or transferred off again upon the tin plate." The rubber roller could "offset" a remarkably sharp image on the tinplate and could also, by the nature of its elasticity, print with solid ink coverage even on hard uneven surfaces. ■ The offset process worked so well that after the 1890s all other methods of printing on tinplate became obsolete. A plus for designers was the fact that the image on the stone could now be rendered "right-reading." Previously, all type and illustrations had to be drawn "backwards." ■ "Canning" foods started as an industry in the first decades of the 19th century. The need to transport preserved foods in nonfragile containers expanded the use of the tin can. The American Civil War introduced the concept of tinned foods to many soldiers who previously knew or trusted only foods "canned" in glass bottles and jars. It seems that Americans, especially, had a pervasive distrust for eating food out of a tin can, and perhaps rightly so. A cookbook of 1890 warns the housewife: "In all tinned foods there is a danger that lumps of solder, used in sealing the tin, may fall inside and be accidentally swallowed with the meat. In turning out a tin of soup they should be looked for in the sediment at the bottom and removed." Fortunately, by the early 1900s the wide-mouth can replaced the older hole-and-cap can that was sealed by means of lead solder. The new "sanitary" can was sealed by specially designed machines to crimp or double-seam the top of the can to the body after it was filled. The tin-can industry soon became fully mechanized, one machine turning out twenty-five hundred cans an hour.

The introduction of new machinery from the 1850s to the early 1900s helped mass-produce many packages that were previously handmade. In this period, the bulk "packing" of foods and products in barrels and crates slowly became "packaging"—the creation of smaller parcels of the same products in specially designed tins, boxes, cartons, bottles, and jars. The biscuit tins in mid-Victorian England had introduced a whole new marketing concept—the package as the product. But the full advertising potential of the package was yet to come. ■ As late as 1920,

only a small proportion of common household groceries (such as coffee, tea, sugar, salt, rice, and flour) were packaged and sold under brand names. But by the end of the decade, the rise of national advertising as seen and heard in newspapers, magazines, billboards, and radio and the growing use of national branding created new opportunities for selling all types of products in small quantities. The brand name and its distinctive trademark were playing a major role in the development of large-scale industry. The housewife in the smallest American town was becoming brand-conscious every time she leafed through her *Good Housekeeping* or snapped on the radio. "Tired of rubbing and polishing your linoleum floors? It's easier with 'Dri-Brite.' Look for the magician pictured on every can." At a chain food store like Red Owl or a five-and-dime like J. J. Newberry, the modern homemaker wasn't asking for cornflakes and soap anymore. She was asking for Post and Procter and Gamble. Brands like Sanka, Crisco, Fab, Cutex, Scottissue, and Baby Ruth were around in the 1920s and are still around today.

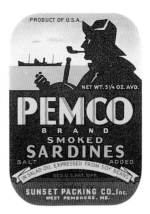

A label printed around the turn of the century, below, is juxtaposed with its thirties redesign, left. The storytelling elements of the illustration have been pared down to the basics.

Trademarks varied from country to country. The Europeans loved geometric and stylized anthropomorphic figures and animals (like the smoking robot of Matador cigarettes). In the United States many comical characterizations found their way into trademarks, like the Pep Boys' Manny, Moe, and Jack. By the mid-twenties, the new Modernist typographic trends from Europe in general and Paris in particular were influencing type trademarks in the United States like Excelsior stamp pad and Eagle drawing pencils. The trademark's traditional function was to identify the origin or maker of the product. As such, the

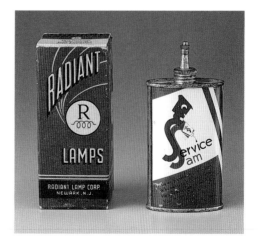

As seen on the Radiant Lamps carton and the Service Sam motor oil tin, Modernist lettering could be dramatic or whimsical.

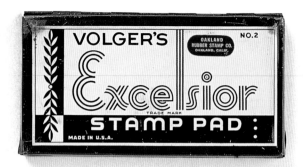

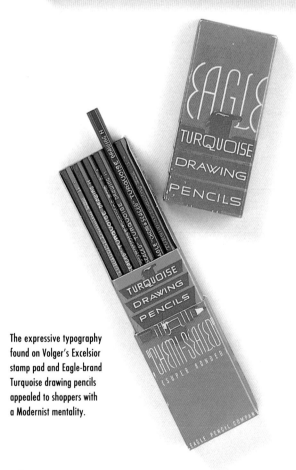

The expressive typography found on Volger's Excelsior stamp pad and Eagle-brand Turquoise drawing pencils appealed to shoppers with a Modernist mentality.

idea of branding a product (once literally referring to burning a mark on a cloth bale or wood cask with a hot iron) was nothing new. The first registered trademark in the United States was the eagle of Averill Chemical Paint Company in 1870. In Britain, the first registered trademark was Bass and Company's Pale Ale red triangle in 1876. Franken and Larrabee noted in 1900 that only 7 percent of product advertisements actually showed the package. By 1925 that percentage was over 35. The brand name guaranteed products, bred confidence and trust in the consumer, and protected the buyer against fraud.

In America, an overwhelming number of new products and product brands were flooding the shelves in retail outlets. By the 1930s, the new American institution, the supermarket, was presenting consumers with a dizzying assortment of product choices that were not very different from one another in price or appearance. With America becoming a nation of impulse buyers, a product's sales pitch—its packaging and the way it was displayed—became essential to trigger impulse buying. The stock market crash of 1929 didn't slow the way advertising was shifting its focus away from the product and onto the emotional and psychological needs of the shopper. In fact, it kicked it into high gear. The heads of industrial empires were huddling with their quarterbacks of motivational research and were diagramming a game plan for curing a sick economy. The strategy was clear: America would have to "spend its way out" of the Depression. Package design, like advertising, had become a recognized profession in the 1920s. This decade also saw the birth of the commercial artist or graphic designer. The same

research methods that Walter Dill Scott had pioneered in advertising were then applied to the copy, graphics, color, and even the size and shape of the box or tin. Scores of older packages, "artfully decorated" in the Victorian era, were being "scientifically designed" in the twenties and thirties. With strong motivational copy and graphics, products could compete better on the shelf and sell themselves. The era of self-service shopping was placing more and more emphasis on eye-catching, easily identifiable, modern packaging. Modern package design, in the period roughly bounded by the years 1920 to 1945, was characterized by one or all of the following elements: simplification, straight-lining, and stylization. It was also referred to as Modernistic and Jazz Age (among other monikers) by commentators of the period. "Stream-lined" was a popular description, especially in the United States during the thirties, when industrial designers ruled the roost of economic recovery. Modernism was as much a philosophy and an attitude as it was a style. At its best, modern packaging design communicated the feeling of the age—optimistic, exciting, and dynamic. It was the age of jazz and jitters, as the business and boom years of the twenties became the Depression and recovery years of the thirties. Modernism was the affirmation of the Machine Age and the recognition that a new culture of consumerism was forming. All styles and movements that extolled the virtues of the organic and the hand-crafted were suddenly the butt of callous derision by the champions of the new order. Art Nouveau, the spaghetti art of the late 19th century, was waning in popularity in the first decade of the 20th. Also called Liberty Style and Jugendstil, Art Nouveau was never just curves and swerves. The design work of the Scotsman Charles Rennie Mackintosh was rectilinear and elegantly austere. Ironically, Mackintosh's prophetic new style stirred great excitement at exhibitions in Vienna, Turin, Moscow, and Dresden, but his work was largely unsupported in Britain. Liked or disliked, curvy or linear, Art Nouveau should at least be credited with breaking away from Victorian historicism. At last designers could create styles of their own that reflected the times instead of tacking on an ersatz-rococo border here or a mock-Renaissance floral pattern there.

The new Machine Age aesthetic came striding into the 20th century with the confidence of a young, burly mechanic ready to crank up the turbos of industry. From the countries that welcomed the straight-line work of Mackintosh, groups and schools sprang up that became the cogs, fly-wheels, and fanbelts of the Modernist machinery—Austria's Vienna Secession, Futurism from Italy, Constructivism from Russia, and the Bauhaus from Germany, along with Dutch De Stijl and American Preci-sionism. The fine-art movements that contributed to Modernism's dynamic geometry were French Cubism, Russian Suprematism, English Vorticism, and Dutch Constructivism. The vivid colors from the costumes and settings for Diaghilev's Ballets Russes by the painter-designers Leon Bakst and Alexandre Benois were a source of inspiration for years to come. On a commercial level, the first Modernist designs executed in the early teens in France for posters, advertising, and packaging were largely non-machine-inspired. The overall feel is decorative, floral, and feminine, an extension of Art Nouveau sensibilities. But after World War I, geometric styles derived from Cubism, Futurism, and other machine-influenced art movements were becoming popular. The landmark

Paris Exposition Internationale des Arts Décoratifs et Industriels Modernes in 1925 helped popularize European modern art and make it commercially acceptible in America. However, the appreciation of all things Moderne was not cultivated in everyone at the same time. Indeed, some hated the bold, new style and graphically retreated to the comforts of Louis XIV pastiches and Victorian revivals. An American report of the Paris show for *House and Garden* magazine "doubted if the modernist movement, as applied to the home, ever gets a strong foothold in this country. Sporadic interest may be shown and a little of the modernist feeling may creep in here and there, but as a people we are not ready for such radical innovations as these." It was the very medium of the monthly periodical that introduced housewives everywhere to the "radical" new style of packaging design. Advertisements illustrating strikingly slim, modishly attired women demonstrated how one could (inexpensively) update one's home with such "modern accessories" as a smartly packaged cleanser like Maguey for the kitchen sink, or a Cubist jar of Moderne Salad Dressing for the dining table. By the late twenties, the new style pioneered and developed in Europe had spread throughout conservative America and the world to become a truly international style.

Like most styles, Modernism had its purists and its showoffs, its Greta Garbos and its Josephine Bakers. The Modernist camp was divided over decoration—those who used it lavishly and those who disdained using a single unpurposeful zigzag or triangle. The British periodical *Communication Arts and Industry* voiced the dilemma in 1935; the trend in packaging was toward simplicity, but it was flirting dangerously close to monotony. Using "the most formal and reticent bit of geometry" for decoration, the publication said, was not producing packages full of force and character, but was simply an excuse for good taste and was taking "the easy way out." ▪ Commercial artists who loved decoration had a special fondness for the flat, fragmented geometry inspired by Cubism, a leitmotif of twenties and thirties Modernism. They applied it unabashedly to everything from cookie to typewriter-ribbon tins. Symbols of power and modernity were designed with panache—Manhattan skylines, speeding cars, soaring airplanes, and zigzagging thunderbolts. Several graphic elements are ubiquitous—ziggurats (stepped forms), raybands (converging lines), and concentric circles. Designers lavished images of fountains, bouquets, elongated figures, and animals on packaging for women's cosmetics. Designs inspired by the exotic arts of tribal Africa, pre-Columbian Mexico, Persia, Egypt, the Orient, and even the folk art of Europe were all strip-mined for graphic themes. The palette was often lively, especially with French packaging—raw oranges and blues, canary yellow, jade and turquoise greens, ruby red and black. Brand names and trademarks could be the whimsical novelty lettering of a Service Sam or the boldly dramatic approach of a Radiant Lamps. ▪ In the hands of hard-line purists, Modernist packaging was restrained in color and design. These designers reduced illustration to the bare essentials, if they used it at all. They retooled the product's lettering, utilizing sans-serif typefaces like Futura, Gill Sans, Kabel, and Bernard Gothic. This reductive form of package design was meant to foster ready product recall, recognition, and identification. The quintessential formulists Franken and Larrabee, in their 1928 book on packaging, broadcast their rationalist spiel: modern commercial art had

become "the art of elimination." Its function was to convey the sales message quickly and forcefully. Fancy scrollwork, meaningless borders, and "freak art" detracted from the selling value and had no place in modern package design. Fortunately, the packaging design of the Modernist period enjoys a democratic continuum of stylistic variations. On the shelves of tobacconists, strikingly rigid designs like the Black and White tin coexisted with the "friendlier" ones like Alouette. Although most designers of the time were anonymous workers for the packaging industry, a few "stars" were recognized by their contemporaries. Lucian Bernhard, noted for his Sachsplakat, or "Object Poster," was a prolific packaging designer in the thirties. Walter Dorwin Teague, an artist who initially specialized in ornate advertising borders, turned his talents to industrial design and created Cubist-inspired glass jars for the Turner Glass Corporation. René Clarke, of Calkins and Holden Agency, designed the critically acclaimed Snowdrift container. Other outstanding figures among the pioneers of modern package design were the "colorist" Arthur S. Allen, Joseph Sinel, Gustav Boerge Jensen, Rudolph Ruzicka, Ayao Yamana, Joseph Binder, and Piet Zwart.

During World War II, the great drain of human energy on all sides slowed developments in the fine as well as the commercial arts. What the war did advance, however, was the technical aspects of packaging, such as the wider use of aluminum foil and transparent wrappings. As far as the graphic treatments of the many tins, labels, and boxes designed and printed in the early forties were concerned, they weren't

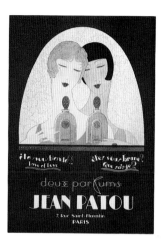

Reynaldo Luza designed Jean Patou's *deux parfums* ad in the twenties with a duo of Modigliani-inspired flappers.

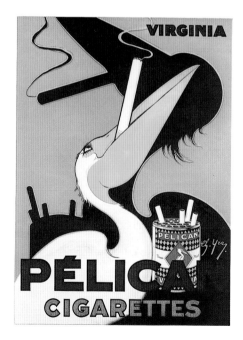

The French poster for Pélican cigarettes, c. 1930, is an example of the witty, bright, confidently designed graphics that inspired commercial artists around the world.

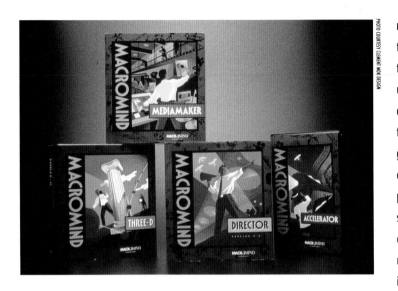

PHOTO COURTESY CLEMENT MOK DESIGN

San Francisco's Clement Mok Design has created a family of computer software packaging with a distinctively Modernist feel. Art Director: Clement Mok/ Sandra Koenig. Illustrator: Ron Chan. Client: Macromind, Inc.

The Fallon McElligott Agency in Minneapolis has developed the name, logo, and packaging items for a food delivery service with a playful retro thirties look. Art director/Illustrator: Tom Lichtenheld. Client: General Mills/Bringer's.

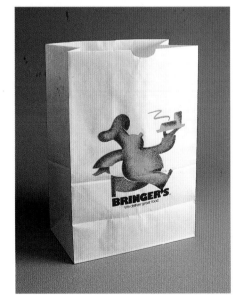

much different from what was being done in the late thirties, outside of the increase in the use of military themes. But changes, however subtle, were still occurring. 🎁 By the early forties, the Cubist-inspired use of broken and overlapping geometric forms was passé. Surreal and amoeba-shaped forms were invading the straight-line world of the little geometric men and supplanting them. This new graphic language was inspired by the work of Salvador Dali, Jean Arp, and others. Although it had been creeping into fashion and other high-end product advertising since the mid-thirties, it affected packaging design somewhat later. 🎁 Once the phenomenon of planned obsolescence entered the packaging industry, it did so unevenly—for reasons having much to do with the complex considerations of packaging itself. Packaging design is inherently more "style-cautious" than advertising or fashion design because it usually must have a minimum "shelf life" of five years for economic viability. Packaging, like the design of a trademark, has a more lasting job to perform than an advertisement placed in a monthly periodical. The quick identification of the product by its graphics, colors, and the size of its container is a vital factor in repeat sales. Of course, higher-end products like cosmetics can afford to change their packaging as often as their fashion-conscious consumers and marketing pressures demand. Cosmetics are commonly contained in expensive custom-made bottles and set-up boxes that are lavishly embossed, hot-stamped, or printed in six or more colors. 🎁 During the forties, with the increasing popularity of printed photography on packaging, photos replaced the stylized graphic illustrations that so much defined the look of the twenties and thirties. The improved technology of printing halftones on paper and paperboard encouraged commercial artists' use

of photography. Public demand for realism could be satisfied with better color printing methods. The direct color camera, which was developed in the late thirties, exposed negatives using yellow, red, and blue for halftone reproduction. Previously, halftone color plates had been laboriously executed by photoengravers. At last, direct color reproduction could realistically convey the luscious flavor of ripe, red cherries on the label of a can. ▣ In the same period, the invasion of script and serif typefaces challenged the hegemony of such thirties sans-serif classics as Futura. The new, lighter typefaces and the more common use of upper and lower case created a softer feel in typography on packaging. The exaggerated proportions and the textural effects of the airbrush that had been applied to Modernist sans-serif typefaces were disappearing due to a shift in design sensibilities. Type inspired by either Bauhaus geometric functionalism or the sensuousness of thirties French poster art came to look in the late forties as obsolete as a streamlined Lincoln-Zephyr. The dramatic use of color and negative space was also being toned down or altered. The machine driving the Modernist style, at times decorative and whimsical and at times clean-lined and full of hard-edged orthodoxy—never really a unified style—had finally blown an aesthetic gasket and come to a rolling halt. Modernism would continue as a philosophy and a style, but the underlying sensibilities had changed, and it was speaking to a new generation of consumers. The style of packaging design that was born in Europe in the late teens and early twenties and that matured and evolved all over the industrialized world in the thirties had run its course by the late forties, or so it seemed. ▣ The revival of the aesthetics of early Modernism in the eighties and nineties has been labeled the "retro" style. A prefix for retroactive and retrograde, the term is a good-natured yet slightly pejorative handle for the self-conscious use of Modernism's component styles—Vienna Secession, Russian Constructivist, Wiener Werkstätte, Streamline Moderne, WPA Style, and others—to influence and inspire contemporary design work. In subtle and in fairly overt ways the graphic language of early Modernism is back in vogue. This eclectic historicism has revived the "dated" Modernist look of Cubist faceting, extra-condensed and machine-styled typefaces, grainy airbrush modeling, and sweeping verticality, as seen in new designs for logos, posters, book jackets, editorial layouts, and illustrations as well as packaging. ▣ The witty and handsomely executed packaging design from Fallon McElligott, Clement Mok Design, Joe Duffy Design and others are reintroducing (albeit in a limited way through specialty goods) Modernist packaging design to stores' shelves. Perhaps, in retrospect, the little geometric men have won out after all. ▣ Currently, original tins, boxes, bottles, and labels of the twenties, thirties, and forties are popular collectors' items. Coffee and tobacco tins that once were easy to locate in local flea markets for a few dollars are now for sale in antique stores with price tags exceeding a hundred dollars. Oil and prophylactic tins are now in particular demand and command high prices. ▣ The following collection of packaging shows some outstanding pieces from this period. Whether included for their vivid color, strong graphics, beautiful typography, or quirky humor, they are all cultural time capsules from an uncommonly creative era of design.

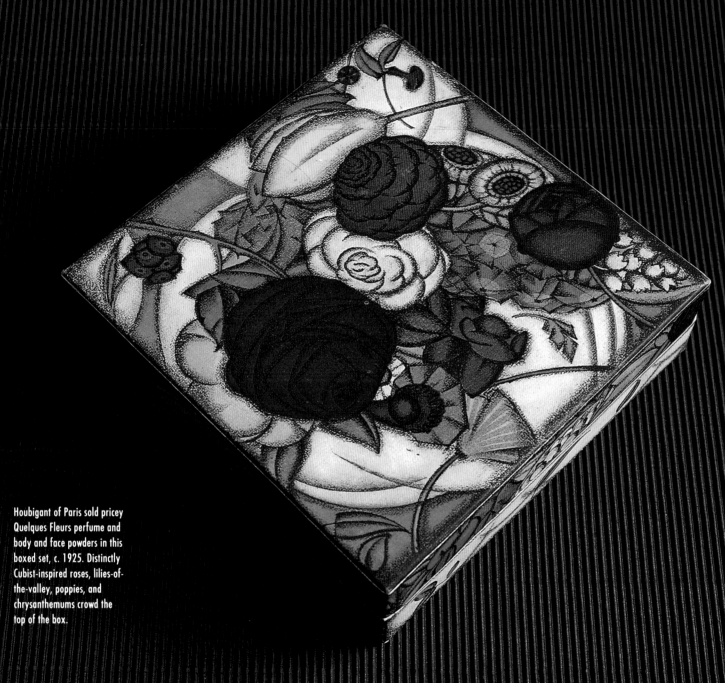

Houbigant of Paris sold pricey Quelques Fleurs perfume and body and face powders in this boxed set, c. 1925. Distinctly Cubist-inspired roses, lilies-of-the-valley, poppies, and chrysanthemums crowd the top of the box.

VANITY FARE

COSMETICS AND GROOMING PRODUCTS

The face of the twenties and thirties was a heavily made-up one. Dietrich, Lombard, Crawford, and other screen sirens were all glamour and sex appeal with their thin, highly arched brows, blue eye shadow, thick mascaraed eyelashes, and raspberry-colored lips. And women of all classes, from Toledo to Tokyo, wherever a movie house existed, were emulating Hollywood for makeup and hair styles. The beauty industry was fast becoming big business. In America, Aldous Huxley wrote, "Soaps, skinfoods, lotions, hair preservers and hair removers, powders, paints, pastes . . . a face can cost as much in upkeep as a Rolls Royce." Because cosmetics tightly orbit the quick-change world of fashion, their packaging must be equally chic. Whether they liked it or not, manufacturers had to give their product lines frequent graphic face-lifts. And they hired some of the best commercial artists to do the job. ▣ All the leading stars of fashion or design of the time either gravitated to or were inspired by the creative output of the undisputed center of haute couture—Paris. Parisian designers were experimenting with the vivid colors and the Slavic and Persian influences of the Ballets Russes for their fashion illustrations, and for poster and package designs. The designs of Erté, Benito, Barbier, Lepape, and Iribe printed in *Vogue* magazine spread a taste for l'esprit moderne throughout the world. The lady's oval handkerchief box (page 33) has a lavishly illustrated scene straight out of Diaghilev's *Scheherazade*. A turbaned woman lounges stylishly in Persian splendor with incense rising in the foreground and minarets towering in the background. ▣ "Taking a powder" was elevated in modern times to a luxury, as the unusual variety of beautifully designed powder tins and boxes demonstrates. All the major cosmetic firms of the period—Coty, Richard Hudnut, Houbigant, and Helena Rubenstein—had their own brands of scented face powders, typically contained in small round or oval packages with such evocative names as Ciel Bleu and Tabu. René Lalique's Airspun was marketed by Coty and looks like a lacquered Japanese box with stylized powder puffs in black, gold, and white floating in a sky of mottled orange and gold. This same design is in production again today. ▣ The geometric shapes inspired by Cubism and the machine aesthetic influenced all types of package design, not least of all cosmetics. The packaging for Gomina Argentine hair cream is like a Stravinsky composition—bold, noisy, and restless. Its raw colors and crude zigzags, arcs, and fragmented planes make it a daring little masterpiece of packaging in the early, untamed Cubist style.

The body-powder tins on these two pages exhibit the rich variety of styles and trends that commercial artists appropriated, to create the identities the cosmetic companies needed to merchandise their products.

E. R. Squibb and Sons of New York marketed its dusting powder in an elegant Greco-Roman package (right).

Two parrots of Oriental design meet against stylized clouds on Le Jade's Aftabath tin, manufactured by the French firm of Roger and Gallet (below).

Ciel Bleu by Cheramy, another French company, is an example of the hard-edged Cubist style (opposite page, top).

The design of Poudre Pour Le Bain celebrates the fractured, restless planes of Cubism (opposite page, bottom).

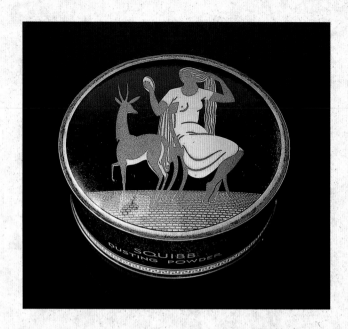

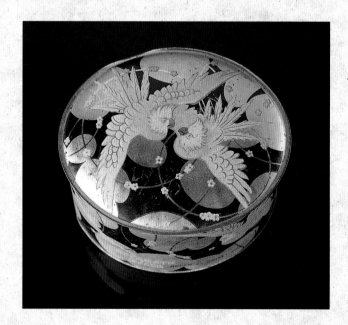

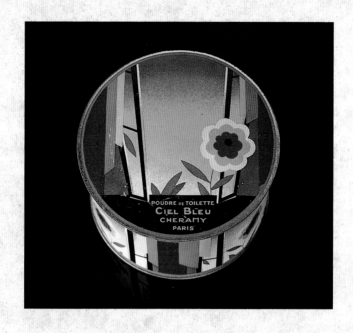

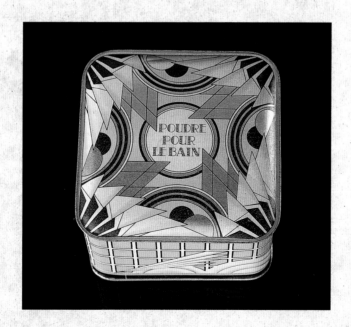

The tins on these two pages all contained the same substance—powdered talc. Their packaging alone sets them apart and establishes their individual identities.

The narcissus is a graphic theme on the left tin (this page), c. 1925. Artistic license has been taken with the color of the blossoms.

Zanol (center) combined a deodorant with its scented talcum powder in this tin by The American Products Company of Cincinnati, Ohio. The party-going woman in a gown of Modernist design daintily holds a tiny black mask, emblematic of Roaring Twenties fact and Depression Era fantasy.

A mythical bird perches on the first letter of Jonteel, manufactured by Liggett's of New York. The bird's crest and tailfeathers mirror in reverse the hooklike form of the "J."

The artifacts discovered in Tutankhamen's tomb in 1922 led to a craze for Egyptian-inspired motifs that were applied to everything from cinemas and furniture to packaging. The four tins on the opposite page, c. 1925-35, play on Egyptian images—hieroglyphics (end pieces), the long, black tresses of a priestess, and a flower-picking maiden.

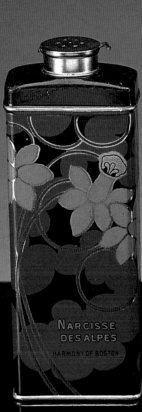

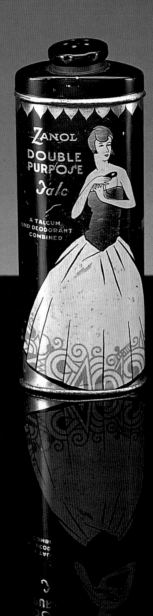

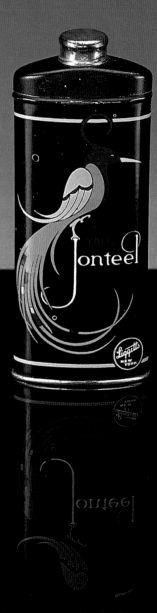

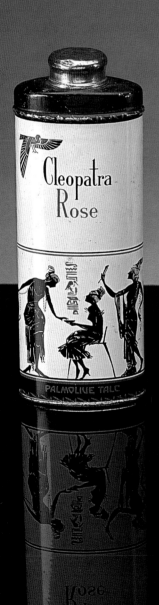
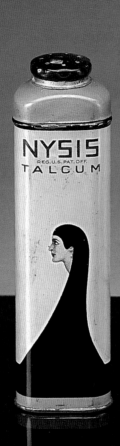
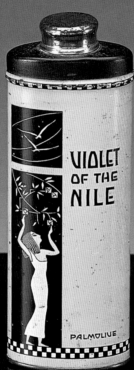
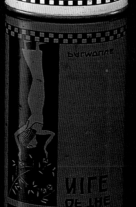
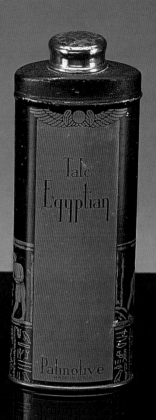

Oval shapes form a woman's demure portrait on the top and an overlapping pattern on the sides of this exquisitely designed container, for L. T. Piver of Paris and New York, c. 1925 (upper left).

In 1908 François Coty invited René Lalique, a successful designer of jewelry and decorative glassware, to create perfume bottles for his company. Lalique's design for the Airspun box with its floating powder puffs, c. 1925, is still in use today and is now identified with the firm's name (lower left).

A woman's crosshatched profile is outlined in dark brown on the cover for Tabu. A broken band of carmine at its base introduces a spot of bright color to an otherwise subdued palette. Manufactured in Mexico by Dana of Paris and New York, c. 1935 (upper right).

Text found on cosmetic packaging aimed at women of color was oddly indirect and obliquely phrased. The square Brown Skin Beauty box, dated 1933, contained face powder blended for "golden complexions" and suggested that this product was the only choice for "people having this type of beauty" (lower right).

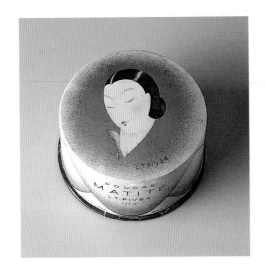

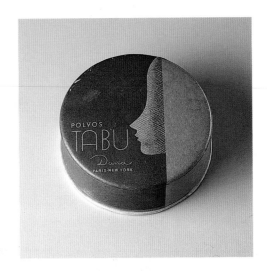

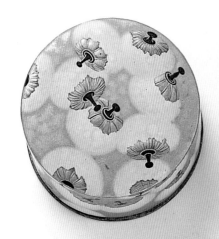

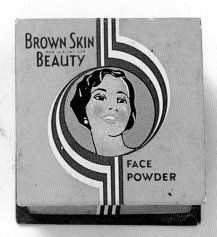

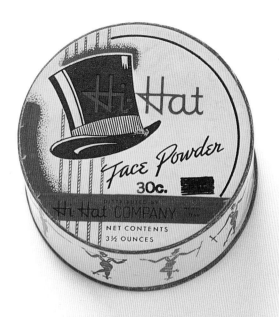

The black and red graphics and typography on the Hi-Hat face powder box seem all the more vibrant against a background of bright chrome yellow. Images of beribboned tap dancers are printed, zoetropelike, on its side, conveying a feeling of happiness and good times. Produced in Memphis, Tennessee, Hi-Hat was blended in shades such as Teezem Brown and Harlem Tan, suggesting the product was marketed for African-American women, c. 1935.

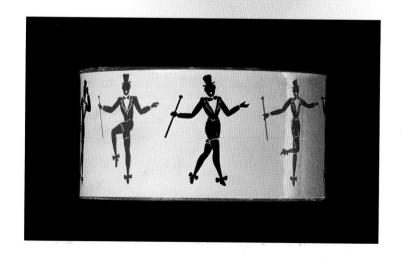

These complimentary trial-size tins containing face powder, rouge, nail white, and bleaching cream would have easily fit in even the tiniest purse. Their graphic themes—cameo silhouettes, women golfers, abstract flowers, and peacocks—were commonly found on all types of women's cosmetics. Cosray face powder, manufactured in Los Angeles, is packaged in a tin that stands out thanks to its strikingly modern design.

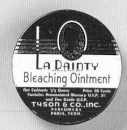

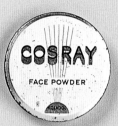

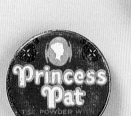

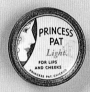

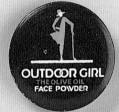

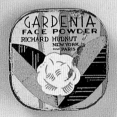

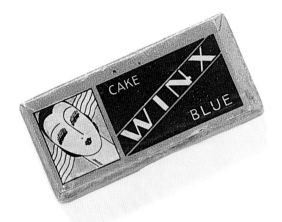

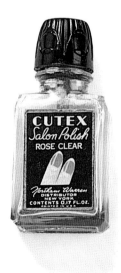

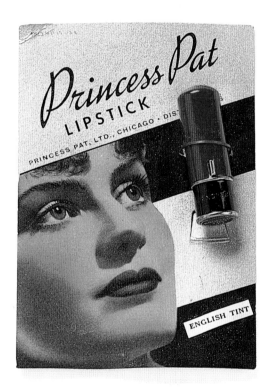

The inexpensive mascara, lipstick, and fingernail polish shown here would all have been found in a Depression Era drugstore.

Manufactured in Chicago, Illinois, Princess Pat lipstick came in shades of English Tint, Light (Vivid), Natural, Orchid, and Tan. Text on the back of the card warned the customer that her lips "will be sought—perhaps more eagerly than she wishes" if she wore Princess Pat.

Packaging for Winx mascara from the Ross Company in New York included the requisite built-in mirror and applicator brush.

On this Cutex bottle cap, made of Bakelite, fingernails are used as a design motif on the bottom. Cutex was distributed by Nathan Warren of New York.

The front panel on "Instant" Clairol's carton sports a die-cut window under which a halved and quartered head with auburn and black hair is pictured. The side panel carries over the black, red, and bronze bands from the front and teams up with amber in a crisscross pattern, dramatically symbolizing a quick color change, dated 1945.

An illustration of the bobby pin is featured on the cover of Sta-Rite along with a fashionably dressed, long-necked socialite, c. 1930.

The collapsible metal tube of hair cream with Bakelite cap and its carton with noisy Jazz-Age motifs were designed for Gomina Argentine in Paris in the mid-twenties.

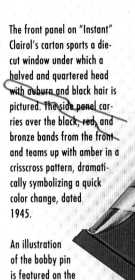

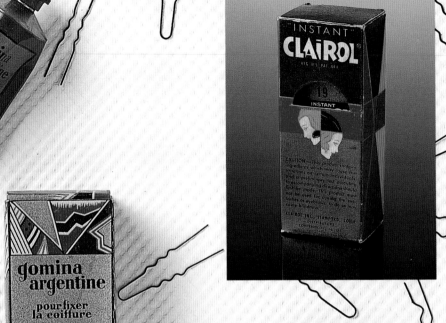

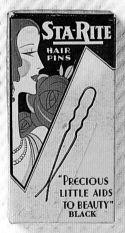

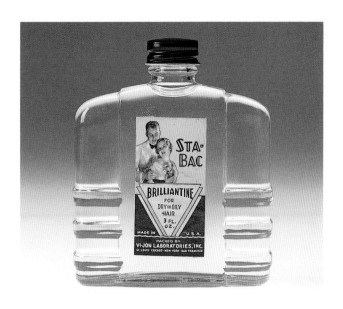

Fashionable women's hair in the twenties and thirties was cut short, worn straight and drawn back from the forehead or set with permanent waves. Men and women alike applied hair oils and creams to keep their coiffures shiny and in place.

Sta-Bac's Brilliantine, manufactured in the mid-thirties, gave hair "the gloss that charms your friends." A photograph of a formally dressed couple is reproduced on the product's label.

Cary Lee hair oil by Royal Manufacturing Company of Duquesne, Pennsylvania, also illustrates a couple dressed to the nines, only in this example they are graphically rendered, c. 1935.

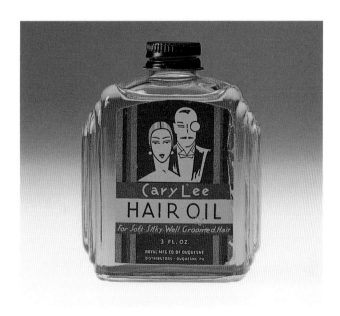

Customer eye appeal was essential for selling cologne and scented toilet soap in the highly competitive Parisian market. Designs changed often and usually reflected the more artistic trends of product packaging. Designed and printed in the mid-twenties, the French labels and wrapper on this page all work the ubiquitous flower motif into varying forms of conventionalized abstraction.

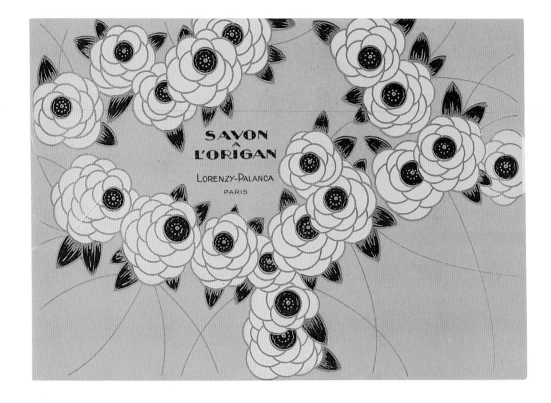

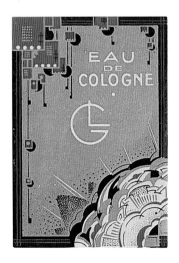

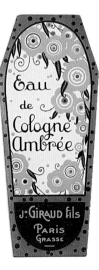

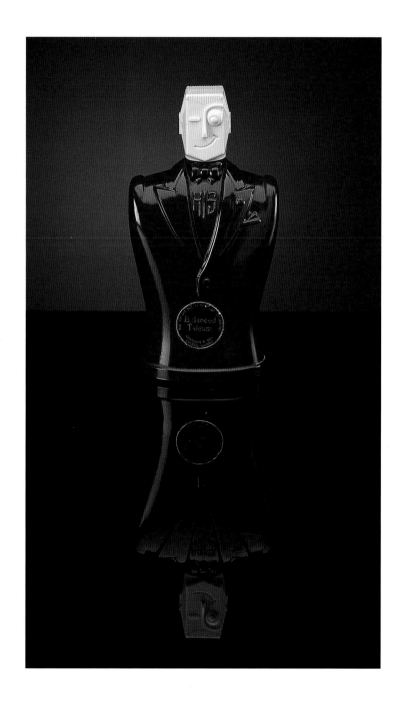

Manufactured for and distributed by The House For Men, Inc. in the mid-thirties, the humorous dispenser for His, a talcum powder, boasts an ivory-colored vinylite "head" as a stopper that fits into the neck of the burgundy-colored glass base, molded to resemble a tuxedo. Vinylite was an early type of plastic developed by the Bakelite Company.

Although its connection with the famous Paris restaurant Maxim's is uncertain, this French set-up box put the cartoonlike image of a uniformed busboy (or bellhop) to good use. It once contained men's collars, c. 1925.

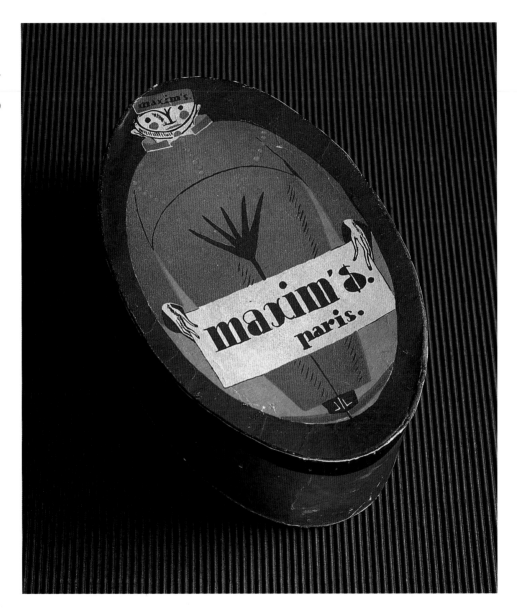

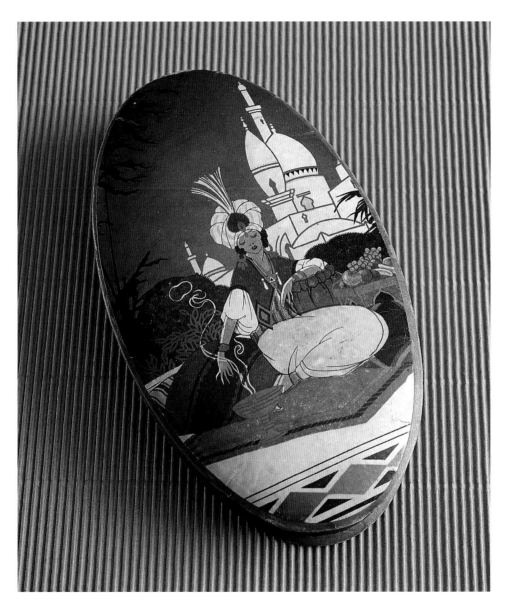

The oval gift box on this page with its scene of Arabian luxuriance, made an attractive package for ladies' handkerchiefs that were sold in chic Parisian department stores such as Galeries Lafayette and Au Bon Marché in the mid-twenties.

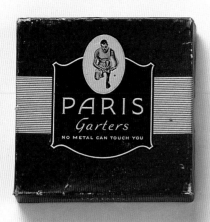

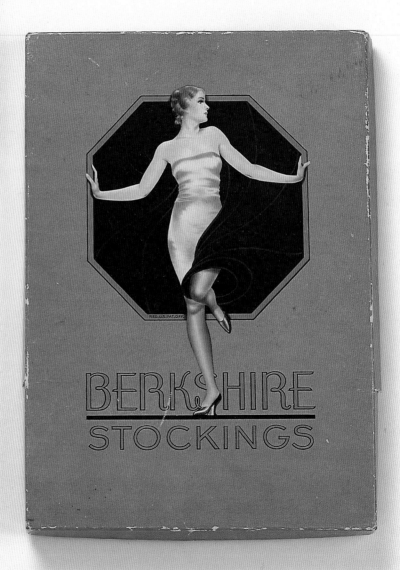

In the early twenties, commercial artists often used frames and mortises that encapsulated illustrations and type to create formal-looking but static compositions. Box-lid graphics for both Paris garters and Berkshire stockings, c. 1920, are composed using this layout method. The styles of illustration that were founded in realism would give way to the flat, conventionalized look that dominated the late twenties and thirties.

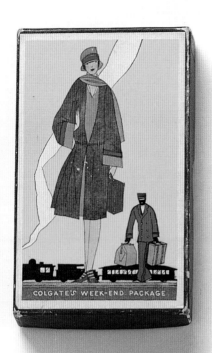

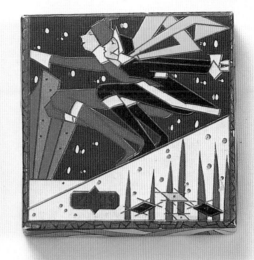

Contrasted with the woman illustrated on the facing page, the Moderne lady on Colgate's Week-End Package is not realistically drawn. Unchaperoned, she stands as a symbol of the new freedoms that women were exercising in the twenties. A stereotypical porter carries the woman's bags in the background. The small set-up box probably contained a tube of toothpaste and toilet soap.

The jarring palette and the strong diagonal lines on this box lid for Paris (containing garters?) create a sensation of movement and excitement, c. 1928.

In 1929, fashionable Bullock's department store opened its doors (including a rear porte cochere) on Wilshire Boulevard in what was then a suburb of Los Angeles. The design of this gift box is a harmonious arrangement of type, concentric circles, and vertical rules, c. 1930.

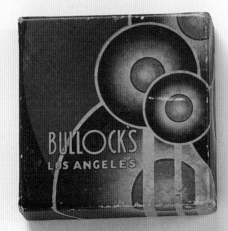

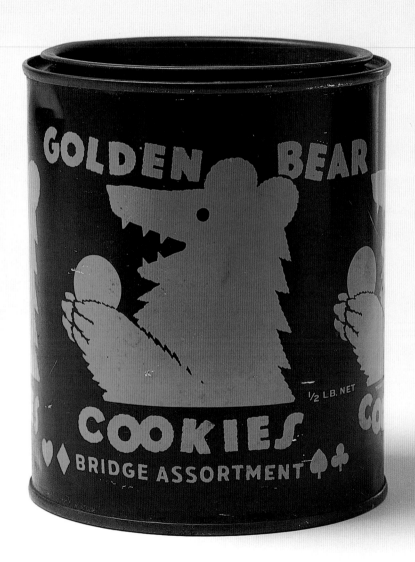

The Golden Bear Cookies tin graphically exploits two symbols of California: its state animal and its state nickname. The cheerful tin and its cookies were created in the 1930s.

GOLDEN BEAR
COOKIES
BRIDGE ASSORTMENT
½ LB. NET

WHAT'S COOKING?

FOOD AND BEVERAGES

The food and beverage industries, traditionally conservative, slowly began to restyle and update their labels, tins, and cartons in the early thirties. It became increasingly evident, even in this somnolent area of packaging, that the new modern look had more visual appeal and impact than other packaging styles. In practical business terms this meant stronger shelf identification of products by consumers and therefore increased sales. Not a bad marketing strategy in any age, and an especially useful one in the years just following the great economic collapse of 1929. The new, simplified use of graphics, typography, and color was fresh and direct, even striking. Next to foods or beverages that retained their Victorian packaging, these modern-looking containers visually leapt off the grocery shelves. Gone were the finely detailed floral etchings and the abundant use of contrasting typefaces. In their place was a reductive and angular aesthetic that employed flat graphics, stylized illustrations, and a predominance of sans-serif typefaces. ■ The Golden Bear Cookies tin perfectly illustrates what the commercial artists of the time were trying to do. Its dramatic, simple use of just two colors—black and orange—creates an unusual and eye-catching container. The stylized bear holding a cookie in its paws is warm, friendly, and comical. ■ René Clarke's Snowdrift Vegetable Shortening tin designed in the thirties uses the symbolic "clean"colors of food packaging: blue and white. Blue is used for the background, and white for the type and columnlike patterns on the sides of the tin, which are meant to represent abstractions of boiling fat—odd subject matter creatively rendered. Its side-panel text boldly states that it is a "rich, creamy shortening for modern cooks." ■ Food packaging of this period often addresses three themes: health, purity, and economy. A tin of cloves from McCormick and Company, featuring a Red Cross symbol on its back panel, informs the consumer that the contents have been "McCorized'—a vacuum process to destroy as many as possible of bacteria and other living organisms that cause certain types of spoilage." During the Depression, when everything needed to last, buying nutritious, high-quality food items that were processed and packaged for minimal product loss became a very real economic necessity in most households across the country.

Thoroughly French in its unabashed use of loud, Cubist-inspired graphics, this tin once contained crackers or cookies. It was lithographed by L'Alutol in the late twenties near Paris.

Soaring skyscrapers in brown and gold against a red-orange background are lithographed on the lid of Pent House Chocolate Tid Bits. The tin is stamped with the mark of the Federal Tin Company of Baltimore, Maryland, c. 1930.

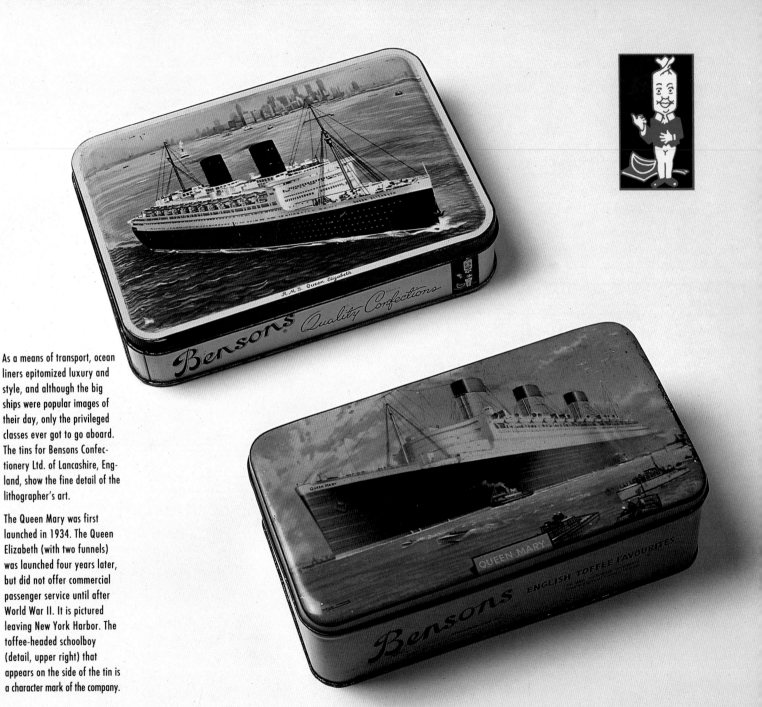

As a means of transport, ocean liners epitomized luxury and style, and although the big ships were popular images of their day, only the privileged classes ever got to go aboard. The tins for Bensons Confectionery Ltd. of Lancashire, England, show the fine detail of the lithographer's art.

The Queen Mary was first launched in 1934. The Queen Elizabeth (with two funnels) was launched four years later, but did not offer commercial passenger service until after World War II. It is pictured leaving New York Harbor. The toffee-headed schoolboy (detail, upper right) that appears on the side of the tin is a character mark of the company.

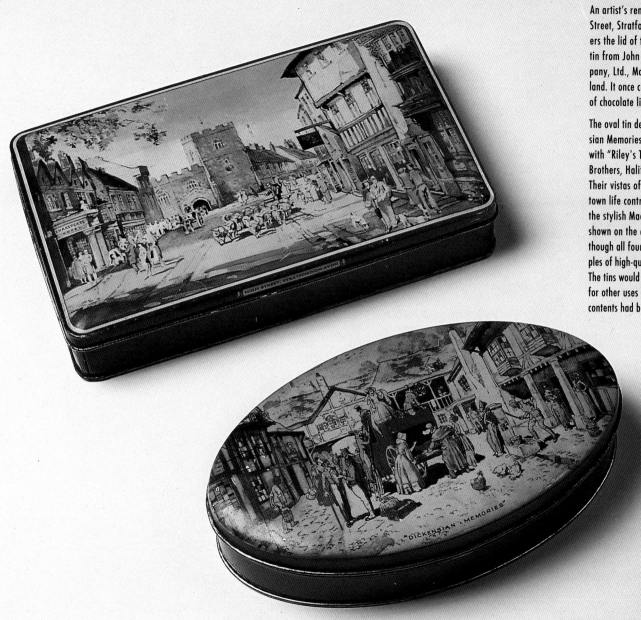

An artist's rendering of High Street, Stratford-on-Avon, covers the lid of the rectangular tin from John Fitton and Company, Ltd., Manchester, England. It once contained a pound of chocolate limes.

The oval tin depicting "Dickensian Memories" is embossed with "Riley's Toffee, Riley Brothers, Halifax, England." Their vistas of quaint English town life contrast sharply with the stylish Machine Age ships shown on the opposite page, though all four tins are examples of high-quality lithography. The tins would have been saved for other uses long after their contents had been consumed.

Combinations of yellow, orange, red, and black connote warmth on these coffee tins of the thirties and forties. Coffee brand names were inspired by Western themes, the coffee-growing regions of the world, and the good flavor of the beverage itself; just as often, the names were the product of pure whimsy.

Bliss coffee, made by Maxwell House Division, General Foods Corporation of Hoboken, New Jersey, has a key-top lid, indicating that it was vacuum-packed.

Berma coffee, produced by the Grand Union Company, updated its packaging in the mid-thirties. The tin on the left sports a detailed illustration of stevedores loading sacks of coffee onto a cart, while the tin on the right has reduced its graphics to the bare essentials of type, line, and color. The ubiquitous dot that divides the product name is halved in the flip-flop convention of Cubism.

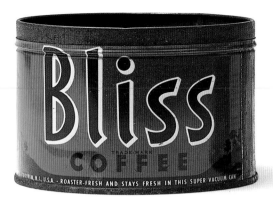

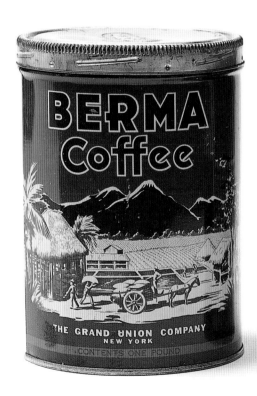

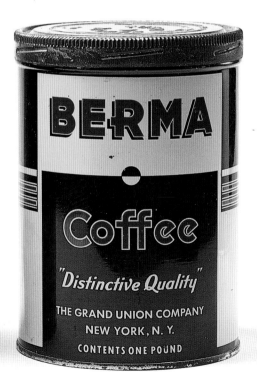

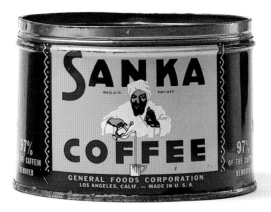

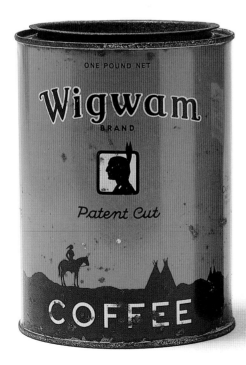

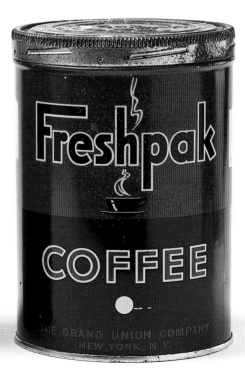

Wigwam coffee, with its sunset silhouette of tipis instead of true dome-shaped wigwams, exploits the romantic myth of the American Indian rather than seeking ethnographic accuracy. Distributed by the Carpenter Cook Company of Michigan.

Freshpak, a brand of foodstuffs packaged by the Grand Union Company of New York, included coffee in its product line. A handsomely stylized coffee cup with rising steam is the centerpiece of the tin. And, like many other containers of the thirties, it employs the solitary dot as an eye-catching graphic device. Sanka coffee, another General Foods product, also has the key-top lid. The image of the Turk pouring coffee is a familiar, albeit stereotyped, character mark.

Thirties aesthetics for advertising and commercial art encouraged novel, unconventional, and even humorous designs as a visual hook to reel in a potential buyer. Hand lettering, unusual imagery, and strong colors worked together to create a look of individuality on even a diminutive spice container. Stylized pictures of Sudanese laborers, oceangoing vessels, stags' heads, and doves are a few of the beautifully illustrated images found on this species of product packaging.

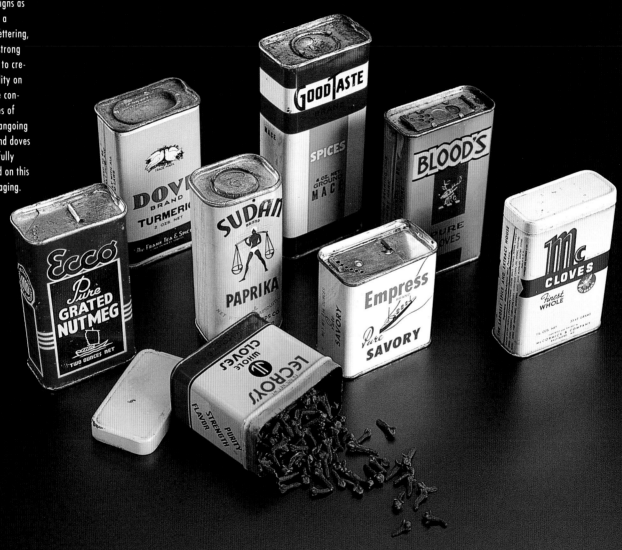

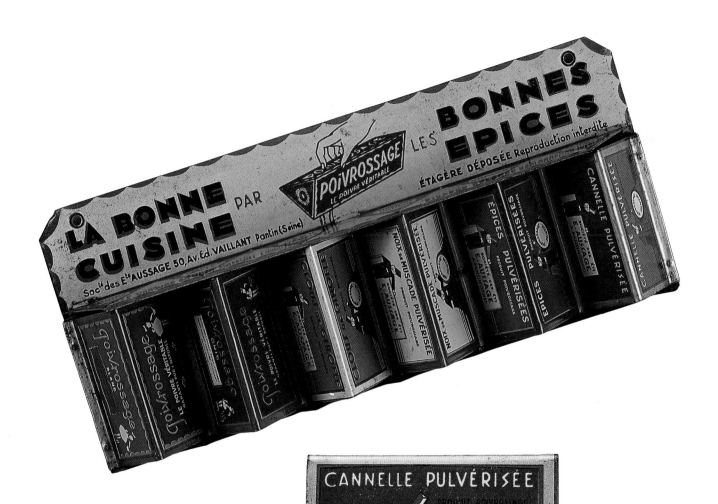

Designed as a spice dispenser, the colorful French tin rack, c. 1930, held paperboard containers that could be refilled with pepper, cloves, nutmeg, and cinnamon. Five of these triangular boxes form the puppet-like character mark that appears on the dispenser.

With the end of Prohibition in 1933, breweries across the country were back in the legitimate business of bottling their alcoholic beverages. Many bottlers took advantage of the thirteen-year hiatus by breaking away from tradition, marketing their beer with labels designed in the spirit of the times. The use of raybands, bright colors, airbrush shading, and images of aircraft in the design of these labels from the thirties were all part of the visual vocabulary of Modernism. To lend a touch of elegance, most of the labels were printed with accents of metallic gold ink.

Although Buckeye, Esslinger's, and Mr. Steinie beer labels lack graphic sophistication, their character marks impart a feeling of good humor and warmth.

Silk Hat's name and the imagery on its label lend status appeal to an alcoholic beverage associated with the working class.

Bottled by Reno Brewing Company, the One Sound State beer label floats a tilted map of Nevada on a sea of crimson.

"Pride of the West" is the boast of the handsome raybanded label for Sunbru beer printed in the rich, warm colors of the Arizona desert.

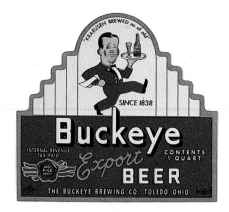

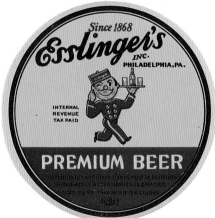

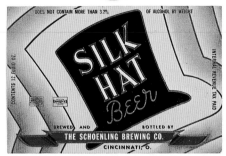

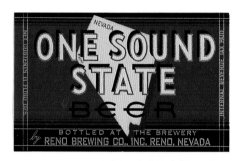

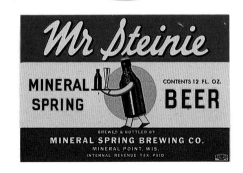

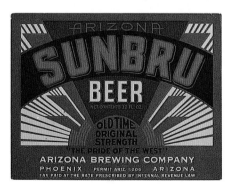

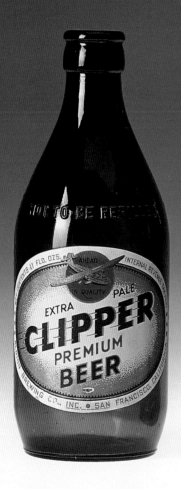
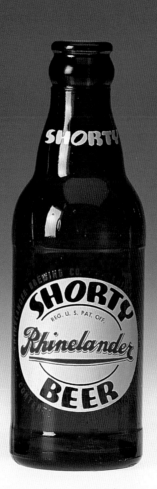
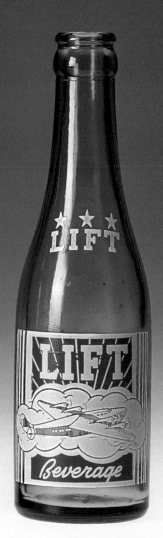

In the soft-drink industry, the new technology of printing directly onto glass (referred to as an applied color label, or more commonly, as a painted label) had all but replaced the glued-on label by the late thirties. Typically screened in a two-color pass, the seven-ounce green bottle was the container of choice among manufacturers, especially in the northeastern United States. Although the painted label made some inroads with beer bottlers, it never gained comparable popularity.

An airplane printed in metallic ink is framed by a red sun on Clipper premium beer. Louis Roesch Company lithographed the attractive label for Albion Brewing Company in San Francisco, c. 1940.

Shorty beer, bottled by Rhinelander Brewing Company in Wisconsin, contained a "short" seven fluid ounces. Screened in white and red on amber-colored glass, it is an uncommon example of beer-bottle labeling, c. 1940.

"Every bottle sterilized before filling" was the assurance screened on the back of the painted label container for the soft drink Lift Beverage of Three Star Bottling Works, Verona, Pennsylvania, c. 1940.

Leon Dupin, the French poster artist, designed the lively counter display for Rita, a brand of gingerbread. Dupin's merry baker hauls a carton of the waffle-shaped cookies, printed in dull earth tones. It was lithographed by Joseph Charles in Paris, c. 1935.

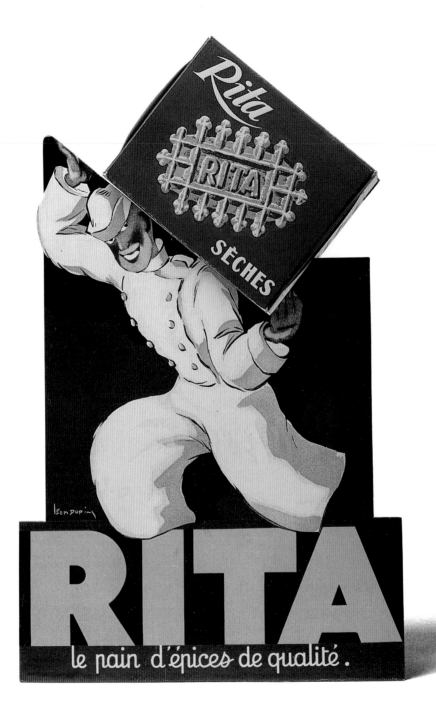

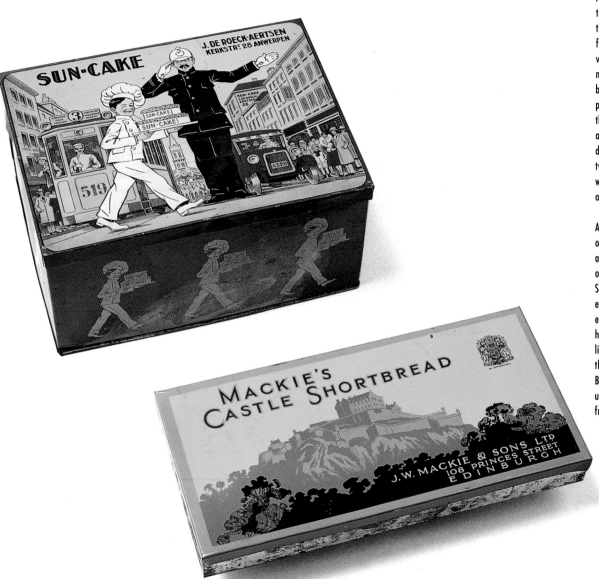

A startled policeman stops traffic for a young baker on the lid of the Sun-Cake tin from Antwerp, Belgium. The viewer's eye is drawn diagonally across the lid from the boy's white uniform to the policeman's left glove and to the manufacturer's name. The automobile in the background dates the tin from the early twenties. The image of the winking baker also strolls across the sides of the box.

A fortress rendered in light ochre and mauve looms against a lemon-colored sky on the lid of Mackies' Castle Shortbread, c. 1930. Heraldic emblems, signs of royal endorsements for products, have been used from the earliest forms of packaging up to the present. One for the British Crown appears in the upper-right corner of this tin from Edinburgh, Scotland.

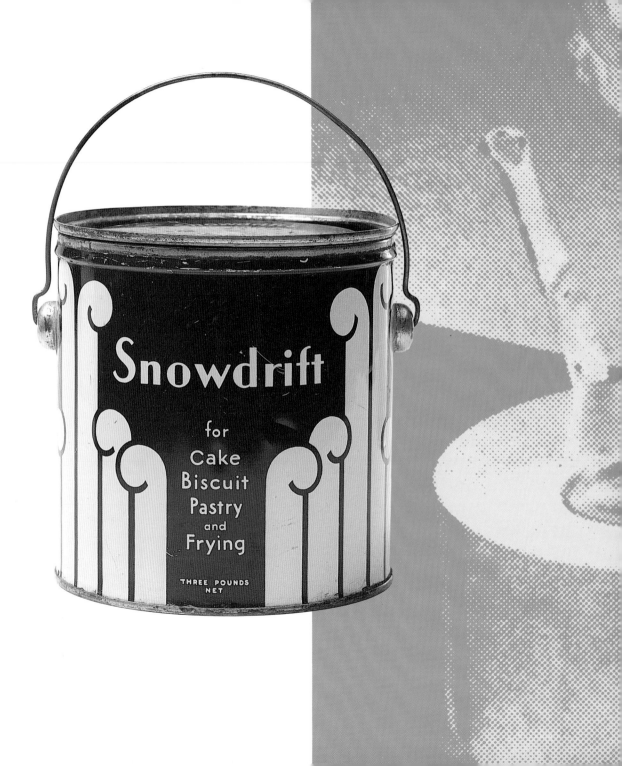

The Snowdrift tin in cobalt blue and white was designed by René Clarke (born James A. Clark) for Wesson Oil and Snowdrift Sales Company, c. 1930. Clarke, art director for Calkins and Holden Agency, was well known for his abstract, Continental style.

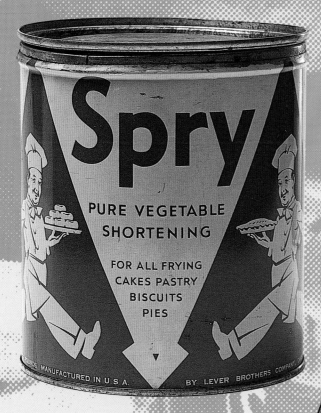

Free booklets offering "tested" recipes were a popular tool for food manufacturers trying to suggest a wide variety of uses for their products. The Spry pure vegetable shortening tin with its two fast-stepping bakers was created for Lever Brothers Company of Cambridge, Massachusetts, c. 1935.

The New Era potato-chip container informs the consumer that its contents are "scientifically processed to make them less fattening and more digestible—EAT ALL YOU WANT." The silhouetted woman posed on a scale reinforces the notion that one can eat one's way to a trim figure thanks to this "highly concentrated energy producing food." It was manufactured by Nicolay Dancey Inc. of Detroit, Michigan. New Era was a proud member of the Potato Chip Institute, c. 1935.

The tin jar lid for LA-Nut brand shelled snack nuts advertises another line of its products—potato chips. Made in Los Angeles in the forties, the lid depicts the company's whimsical character mark, a smiling nut with rifle in hand guarding a walnut asylum.

As if to avoid confusing its customers, the makers of this salad dressing translated the product name—Moderne—below in English on the label. Walter Dorwin Teague, one of the "Big Four" industrial designers, created the jar in 1931 for the Turner Glass Corporation.

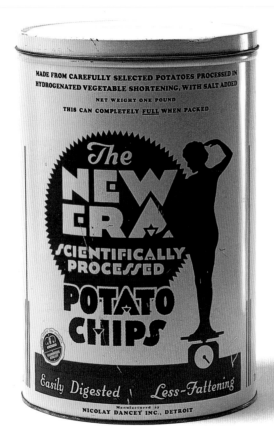

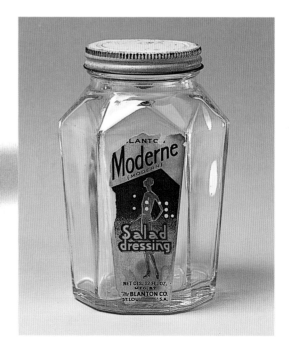

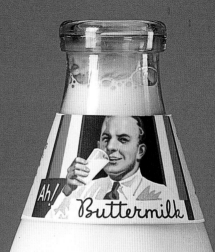

Firmly planted on an I-beam that hovers in midair, the construction worker on this bottle literally illustrates that "milk balances your diet." The painted label is vintage 1935.

Customers placed buttermilk and sour cream paper collars over the necks of empty milk bottles to alert the milkman of a special delivery order. Both collars were printed by the Wolf Envelope Company of Cleveland, Ohio, c. 1935.

Waxed paper caps like these from Wagner Dairy sealed the openings of the thirties-style returnable milk bottle.

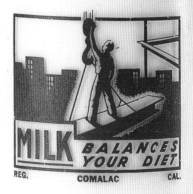

Matina Cémoi's crowing rooster is an apt symbol for this powdered breakfast drink made in France, c. 1928. It is one example of many containers that had a secondary use after the contents were consumed, in this case, as a pantry tin. This particular cocoa package was targeted to have a second life as a rice canister.

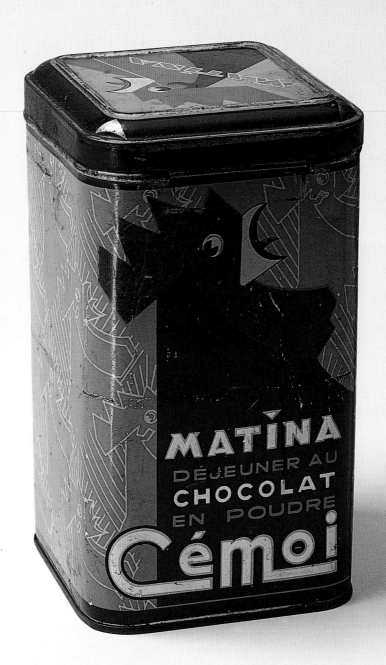

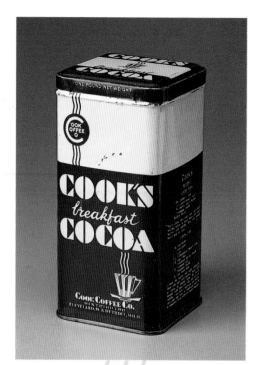

The stylized waves of steam rising from the cup on the Cook's breakfast cocoa tin, c. 1935, are mirrored in the company's logo. Distributed by the Cook Coffee Company, the cocoa tin's strong horizontal and vertical graphic elements along with its geometrically inspired typeface make its design quintessentially Modernist.

"The best gasoline for the human engine" reads the text on a tin for Diase, a French cereal product. Another panel of the container can be seen as part of a gasoline pump. The muscular male nude, a metaphorical automobile, braces himself, pump in hand, ready to tank up on nutrition. Progil Laboratories manufactured the "super-aliment" in Paris, c. 1930.

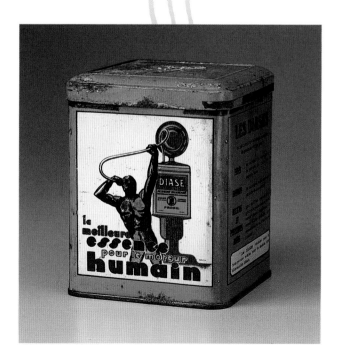

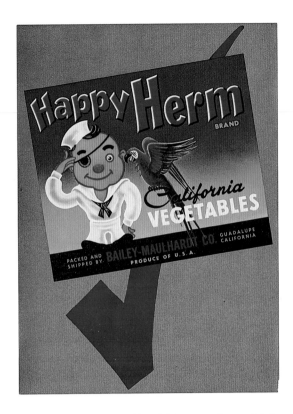

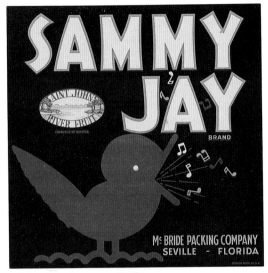

Commercial artists designed the labels on this page from the mid-thirties to the mid-forties to identify and advertise the wooden boxes of fruit and vegetables that were being shipped throughout the country.

Hand-lettering on the Cal-Art label for California Artichoke and Vegetable Growers makes it a standout with its bright colors and airbrushed gradation.

The Sammy Jay brand character mark loudly sings the praises of its boxed Florida fruit. It is a charmingly naive example of simple, flat color graphics, dated 1935.

Happy Herm's jaunty cartoon sailor, replete with the trappings of the nautical profession, was featured on the label for Bailey-Maulhardt Company produce.

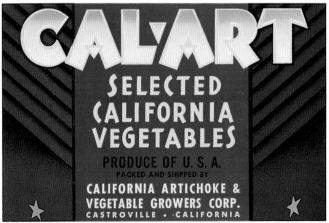

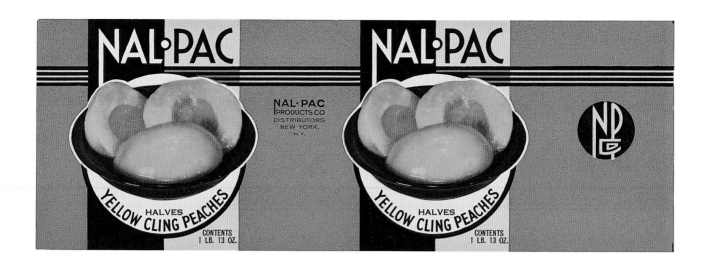

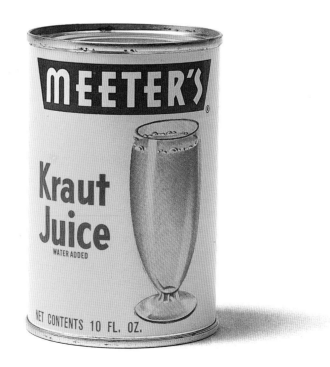

The packers of Nal-Pac yellow cling peaches and Meeter's kraut juice believed that showing the product was the best way to sell it. Both can labels, c. 1932, were printed using Ben Day screen dot patterns, the precursor of today's four-color separation process. Nal-Pac products were distributed out of New York. Originally from a family-owned company, the kraut juice is now produced under the same name by Stokely, U.S.A., Inc. in Oconomowoc, Wisconsin, and can still be found on supermarket shelves with its original label design.

FOR YOUR PROTECTION

HEALTH CARE PRODUCTS

By the twenties modern men and women were stocking their medicine cabinets with a colorful assortment of containers for ointments, aspirins, adhesive bandages, and foot powders. Inventive new closing devices were adapted for all types of oval and oblong tins. Although perforated revolving sifter caps were hardly a new invention, they continued to be refined in ways that helped dispense the product cleanly and in just the right amount. Pebeco tooth powder, for example, in the "clean" blue and white oval tin, was the preferred form of dentifrice for many brushers through the forties. Colgate sold toothpaste to the public in collapsible metal tubes as early as the 1890s, but decades of advertising were required to vanquish its powdery competitor. Like today's consumers, the smart set of the twenties was reluctant to trade one tried-and-true form of packaging for another. Natural latex condoms that were "electronically tested for consumer protection" were discreetly sold in small hinged-lid tins or folding cartons at about a quarter a container. Covers illustrated with inspired scenes of fighting Spartans, pheasants, and gun-toting sheiks contrast sharply with mundane contemporary condom packaging,

with its predictable vignettes of lovers entwined on a secluded beach. A society that insisted on increased uniformity and standardization in its products and its packaging couldn't help but apply these same expectations of conformity to the human body. Advertising, not unexpectedly, reinforced this endeavor. The advertising copywriters of the twenties used the ready-made paradigm of the machine—efficient and smooth-running—as a free-floating metaphor for the many "tune-ups" needed by the less-than-perfect human "engine." Headaches, bad breath, dandruff, body odor, pimples, and other annoying physical disrepairs could now be easily "fixed" by the new mechanics of chemistry and pharmacology. In fact, the bane of the smooth-running engine—constipation—had become a national obsession by the thirties. Bran cereals were heavily advertised for the "regularity" of the whole American family. Laxatives in powdered, pill, and candy form were packaged in all types and sizes of tins. Brand names ranged from the descriptive (Quickies) to the exotic (Sara'ka) to the rather ominous (O-D). "People who do not feel just right" were directed to try Captain John Orderleys' tablets, which contained strychnine as one of its active ingredients.

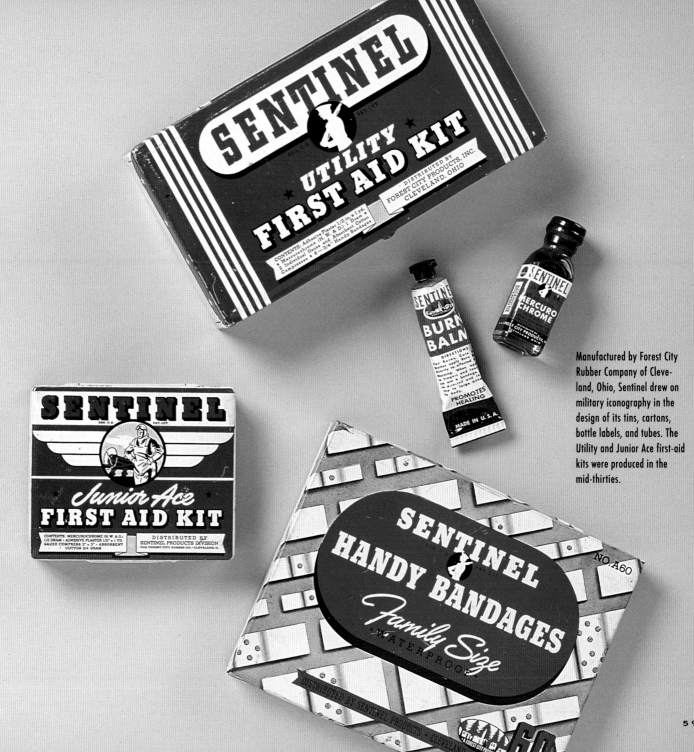

Manufactured by Forest City Rubber Company of Cleveland, Ohio, Sentinel drew on military iconography in the design of its tins, cartons, bottle labels, and tubes. The Utility and Junior Ace first-aid kits were produced in the mid-thirties.

Dating from the thirties and forties, the paperboard and tin condom packages on these two pages each contained three prophylactics "sold for the prevention of disease only." The condoms were made of natural liquid latex and were individually banded.

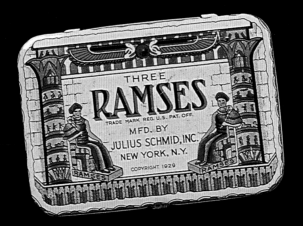

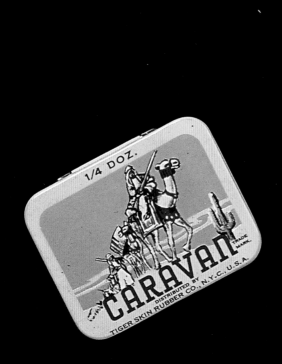

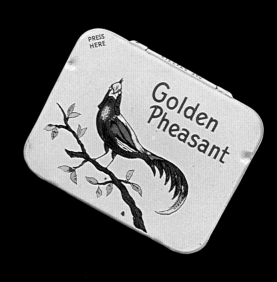

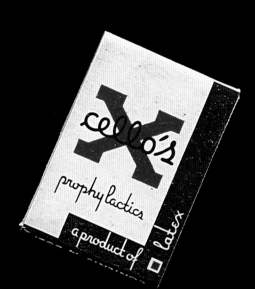

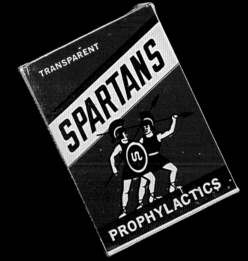

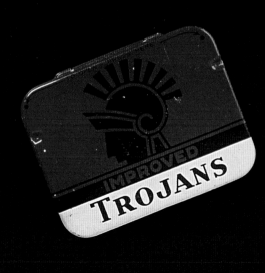

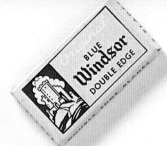

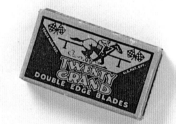

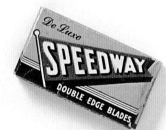

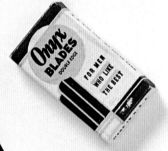

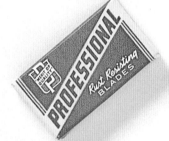

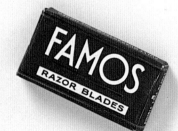

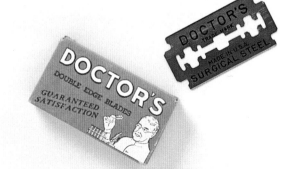

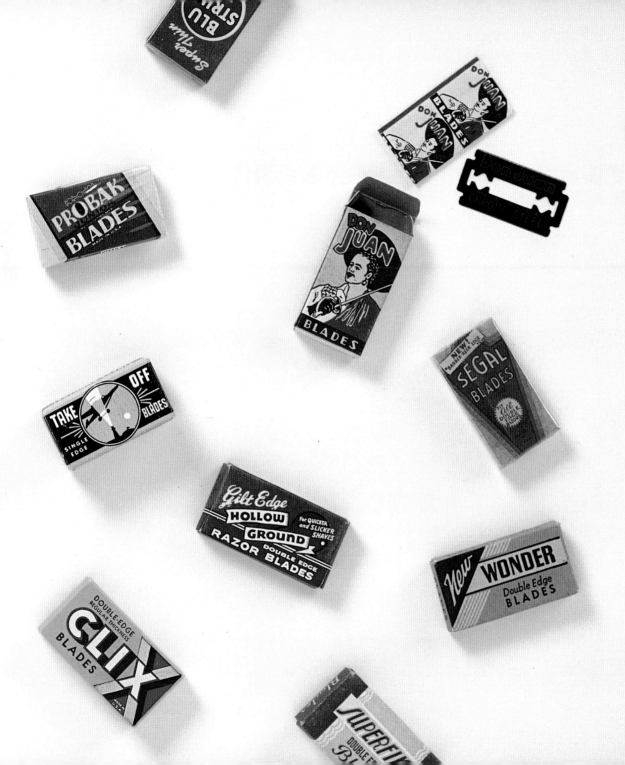

Manufacturers of everyday necessities used graphic design as a tool to help customers distinguish one brand from another, even though the contents were virtually identical. Usually printed inexpensively in two colors, these small folding cartons for disposable blades used allusions to romance, the sporting life, and medical science to attract buyers, c. 1930-45.

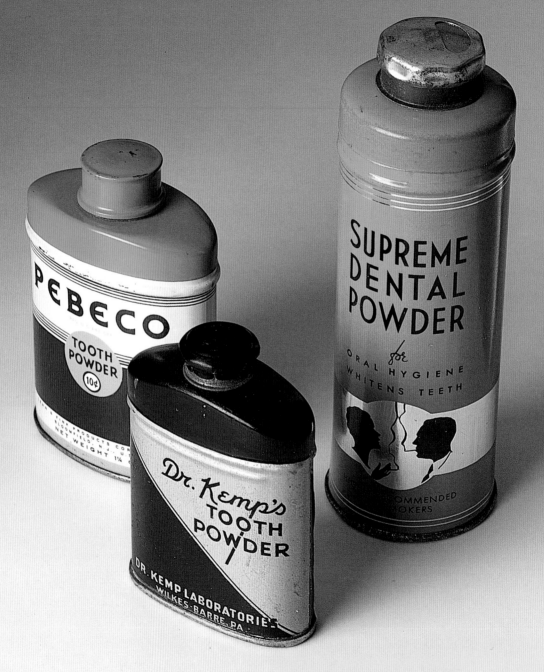

Although toothpaste sold in collapsible tubes began to dominate the dentifrice market by the thirties, tooth powder could still be found on drugstore shelves decades later. The three tins pictured here date from the thirties and the forties.

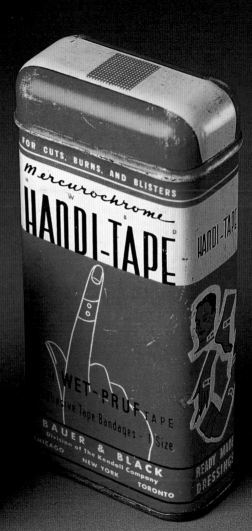
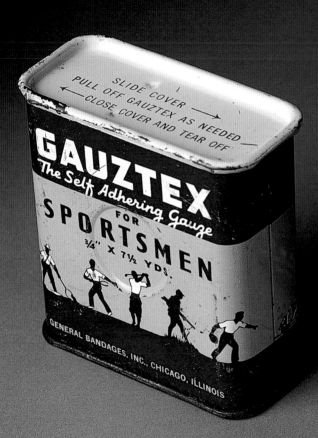

Made by General Bandages, Inc. of Chicago, Illinois, Gauztex illustrated a variety of sporting activities that might create a need for the self-adhering gauze, dated 1939.

The "wet-pruf" Handi-Tape tin by Bauer and Black dates from the mid-thirties. In a somewhat bizarre conceit, a bandaged finger points to the product name on the front panel; illustrations on a side panel demonstrate ways in which the product could be applied to other parts of the body.

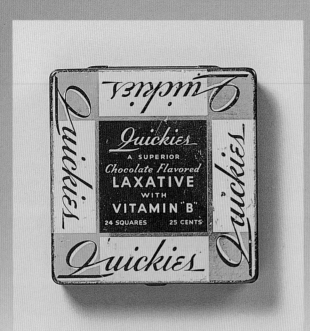

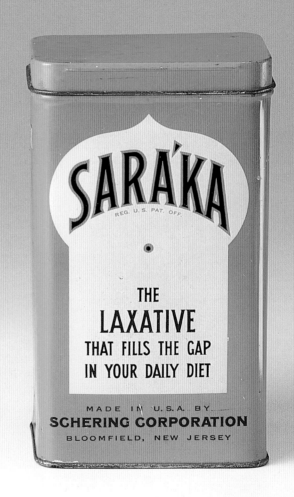

Sara'ka, the laxative that supplied "bulk with motility," was made by the Schering Corporation of Bloomfield, New Jersey. This package redesign of 1937 used a minaret motif to lend an air of Oriental exoticism.

The brainchild of Prescription Products, Inc. of New York, chocolate-flavored Quickies laxative applies the traditional colors of chocolate packaging (brown, cream, and gold) on its container, c. 1940.

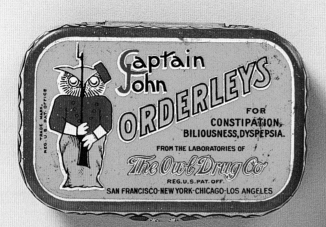

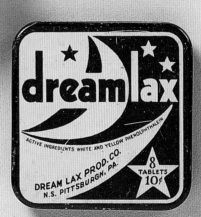

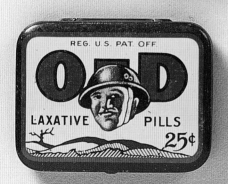

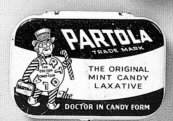

Captain John Orderleys' tablets contained strychnine for its "general tonic effect." The detailed tin dates from the late twenties.

The product name and graphics for Dream Lax suggest that bedtime was the best time for taking this laxative made in Pittsburgh, Pennsylvania, c. 1935.

A pill-shaped doctor was the character mark for Partola, a candy laxative manufactured in Chicago, c. 1935. An order form provided inside the tin reminded consumers that twice-daily "evacuation" was necessary for the health and strength of the human body.

O-D laxative pills came in a handsomely lithographed tin of military theme. "Puts you over the top" was the company's motto. Made in St. Louis in the twenties, these pills were accompanied by a brochure that also recommended O-D as a remedy for bad breath, belching, pimples, and bloodshot eyes.

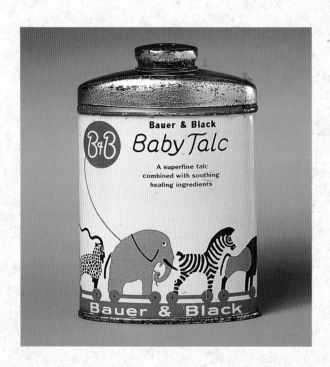

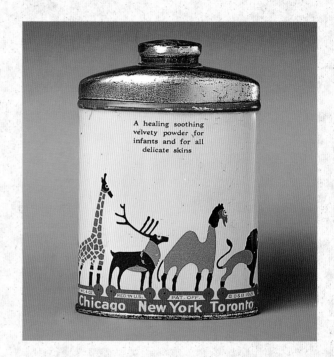

A tidy row of toy animals encircles the base of this container for Bauer and Black Baby Talc. Dated 1921, the stylized rendering, combined with an airy use of negative space, make this a remarkable example of early Modernist packaging design in the United States.

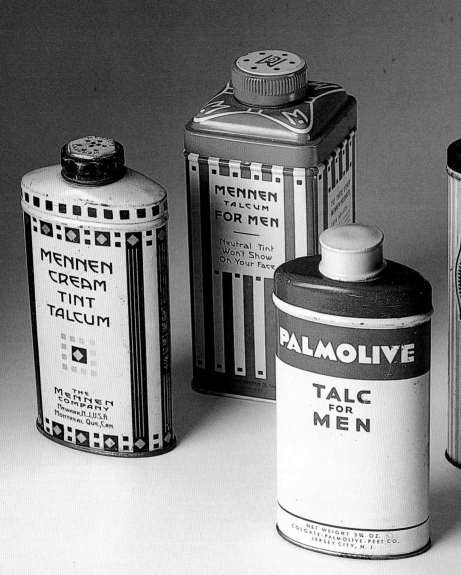

The Palmolive After Shaving Talc tin on the far right was designed in the early twenties with a decorative frame that was widely used at the turn of the century. Redesigned in the thirties, the new streamlined Talc For Men container became a leading seller.

The Mennen Company was one of Palmolive's main competitors in the men's talcum powder field. The tin on the far left was designed around 1920 and demonstrates the Vienna Secession's love of decorative squares and parallel linework. The rectangular tin behind it reflects a thirties redesign: the size and number of squares have been reduced, the stripe pattern amplified, and new colors added to evoke a feeling of minty freshness.

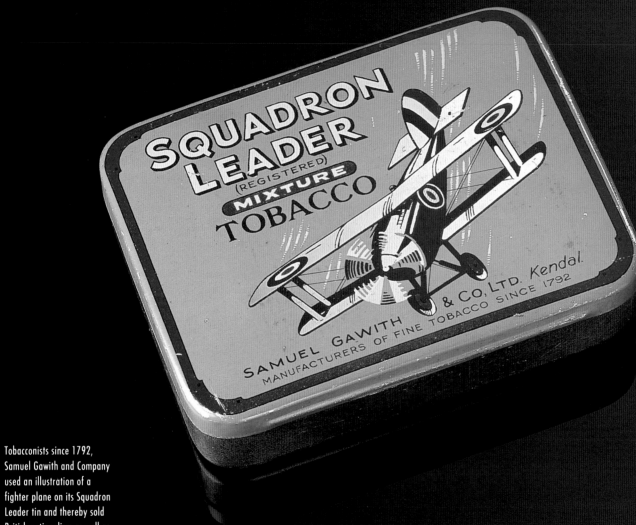

Tobacconists since 1792, Samuel Gawith and Company used an illustration of a fighter plane on its Squadron Leader tin and thereby sold British nationalism as well as tobacco, c. 1930.

SMOKE GETS IN YOUR EYES

CIGARETTES AND SMOKING ACCESSORIES

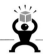

In the spring of 1940, the president of American Tobacco, George Washington Hill, bet Raymond Loewy, the most flamboyant of the "Big Four" industrial designers, that Loewy couldn't improve on the package design of Lucky Strike cigarettes, American Tobacco's premier product. One month later, Loewy won the bet and pocketed a cool fifty thousand dollars. The designer's solution: replace the old green background with a white one. The tenet of purist Modernism—subtract before you add—couldn't have been applied more perfectly.　The creation of functional yet attractive packaging for tobacco products, which must be kept in sealed containers to retain their moisture, was a challenge in itself. Along with a variety of airtight tin sizes, the classic American cigarette package employed cellophane film (invented in 1912 by the Swiss chemist Jacques E. Brandenberger) along with foil and paper to keep its contents fresh and clean for months. Camel, Winston, Chesterfield, and Lucky Strike may have dominated the U.S. cigarette market, but such other Yankee brands as Skeet and Happy Hit also had their addicted fans, who bought these cigarettes in similarly designed protective packaging.　In the United States, the pocket tobacco tin for pipe or cigarette smokers was an especially popular form of packaging from 1905 to 1935. The tin's flattened design and rounded corners allowed it to slip comfortably into a jacket pocket. Its small hinged lid made spilling the tobacco less likely, too.　In Europe and Canada, the square flat tin or paperboard box was the norm for cigarette packaging. The DuMaurier case is designed with elegant Modernist restraint. Originally marketed by the London firm of Peter Jackson in 1929, it was the first cigarette to have a filter tip and was targeted at female smokers, a growing share of the cigarette market.　The tobacco industry, a leader in consumer packaging and brand identification since the 19th century, poured advertising dollars into national magazines and radio in the twenties, thirties, and forties. Millions of men and women were inculcated with the message that smoking calmed the nerves, enhanced performance, and aided digestion. Smoking was also depicted as something the generally successful, social, and health-minded person did—and did often. For children awaiting the consumer benefits of adulthood, there were chocolate and bubble-gum cigarettes, of course.

Lucky Strike cut-plug tobacco first used the bull's-eye design on a green background in the 1870s. The American Tobacco Company adapted the logo for Lucky Strike cigarettes in 1917. The packaging remained virtually unchanged until Raymond Loewy introduced the white background in 1940.

Skeet cigarettes aimed to please the 1936 consumer. They were produced by The Axton-Fisher Tobacco Company of Louisville, Kentucky.

The American Tobacco Company targeted its Happy Hit cigarettes for the watchful smoker, c. 1935.

Designed in Mexico in the thirties, the Alas package's dynamic V-shapes create an airplane and the cigarette's namesake—a pair of wings.

The wrapper design for Campeones cigarettes boldly evokes the Modernist spirit. Profiles of three "champions" cast ambiguous shadows in this classic example of commercialized Cubism, c. 1928.

Caravan was a brand of French candy cigarettes. Each handsomely designed pack contained ten milk chocolate "smokes," c. 1930.

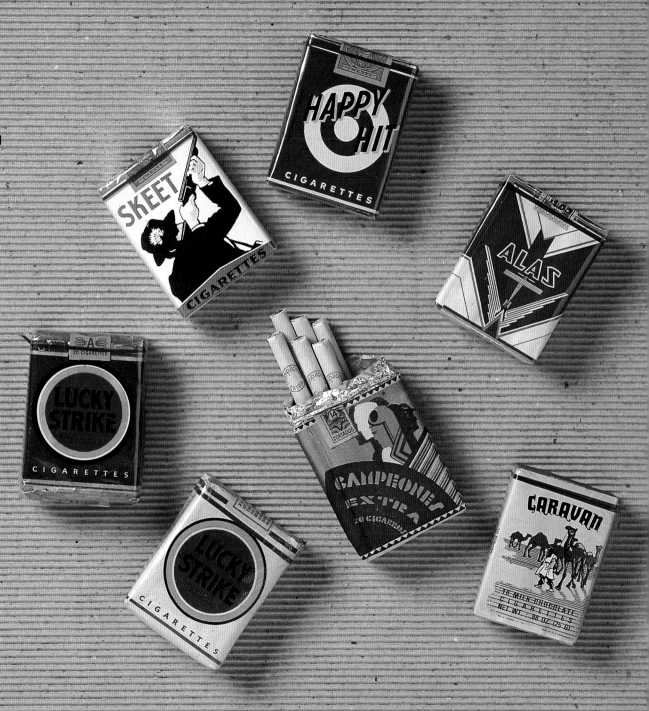

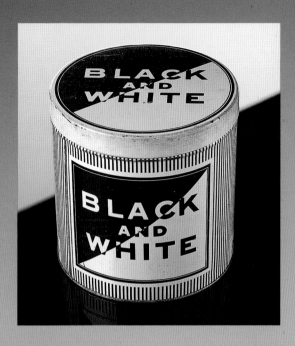

The sparely designed Black and White tin was the cigar buyer's yin and yang in the mid-thirties.

Target's cigarette tobacco tin uses strong color and two basic geometric forms—the triangle and the circle—to create visual impact. Manufactured by Brown and Williamson, the text on the side of the container informs customers that "rolling your own" will cost half the price of ready-made cigarettes.

A chipper lark is illustrated on the front of the Alouette smoking tobacco tin designed in the thirties. The tin was made in Montreal for B. Houde and Gothé Limited.

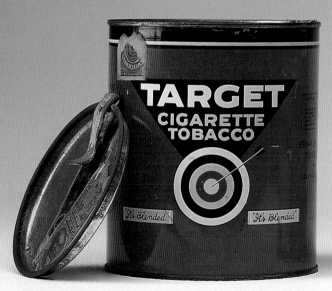

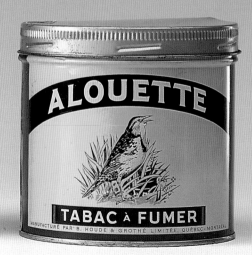

73

The popularity of comic strips and animated cartoons inspired commercial artists of the twenties, thirties, and forties to create whimsical character marks of their own.

Model smoking tobacco's mustachioed mascot—pipe permanently fixed in mouth—has been transformed into an absurd cigar-store Indian in this forties counter display.

Its bold color and logo emphasize the cartoonlike quality of Model's pocket-sized tin, manufactured by the United States Tobacco Company, c. 1940. Purchasers used the corrugated strip on the bottom of the can to strike their matches.

The illustration on Holiday's pipe mixture tin by Larus and Brothers Company of Richmond, Virginia, places the viewer on a tropical island as a distant ocean liner passes by, c. 1935.

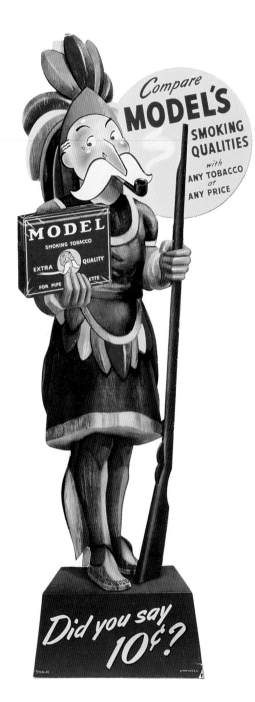

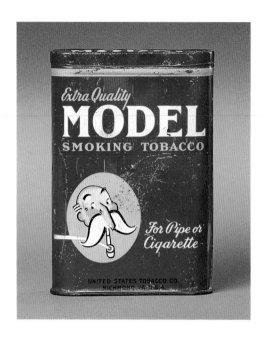

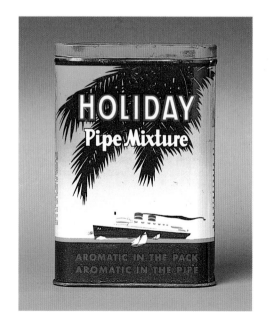

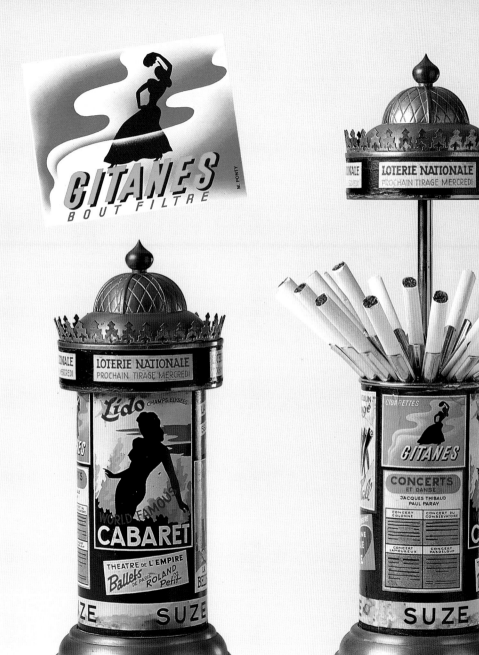

The tabletop kiosk is a clever cigarette dispenser in disguise. Among the "posters" that cover this novelty item from thirties Germany is one for Gitanes, a French cigarette.

The Gitanes cigarette box is contemporary. Its appeal after over sixty years is a tribute to the strength of M. Ponty's design.

Brown and Williamson commissioned the Batten, Barton, Durstine and Osborn Agency to develop a campaign around a yet-unnamed cigarette. "Kool" was selected from among 350 names. The agency also designed the product label, package, and character mark—the genial penguin, Mr. Kool. Later redubbed Willy, he and his spouse Milly appeared in ads and on cigarette-related items throughout the forties.

The Kool self-service tin rack supplied to stores by the makers of Kool cigarettes relied on the honor system to sell matches at a penny apiece.

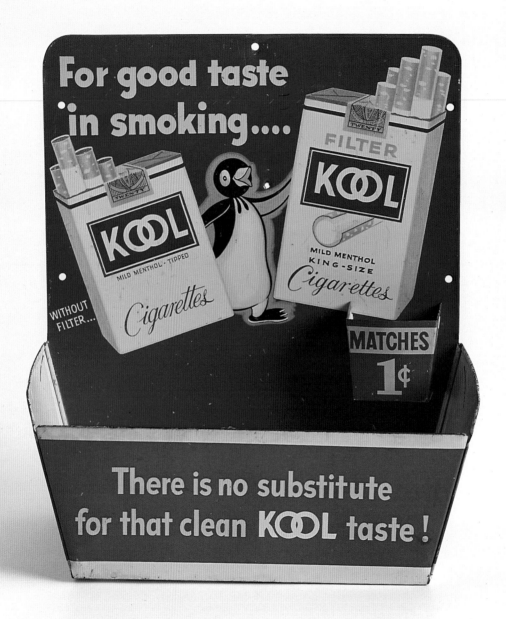

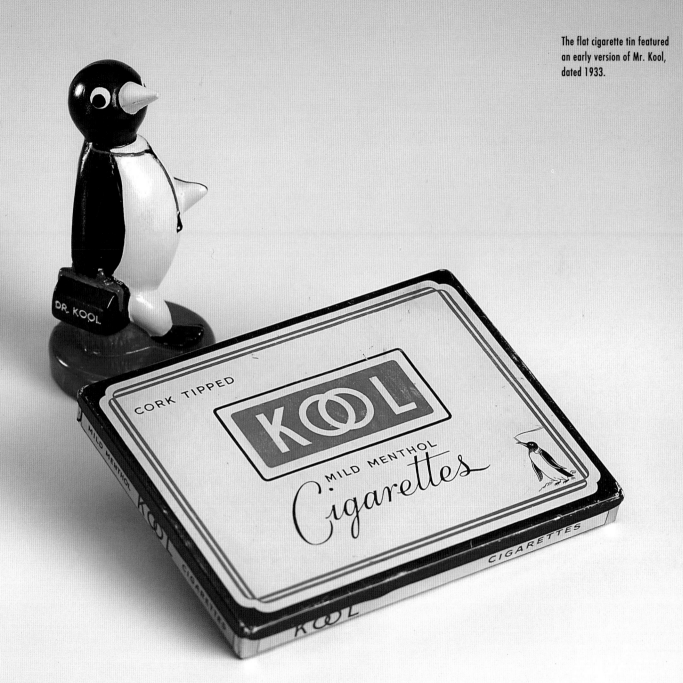

The flat cigarette tin featured an early version of Mr. Kool, dated 1933.

Appealing to the well heeled, the lid of a Fijnproever tin is illustrated with a monicled gentleman in formal attire. Printed in Holland in 1928, the design curiously juxtaposes sinuous Art Nouveau-styled smoke with straight-lined Modernist typefaces.

The lid of Eisenlohr's Cinco cigar tin makes a minimalist statement. Three simple words float on a field of Prussian blue; the sides of the tin carry a frenetic Cubist-inspired design, c. 1928.

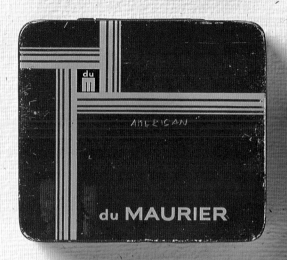

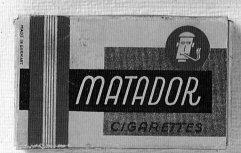

Marketed for the growing number of female smokers, the Du Maurier tin was redesigned in 1929 with elegant restraint. It was made of aluminum rather than steel—unusual for its time.

The paperboard sleeve for Noblesse filter cigarettes was manufactured in Lydda, Palestine, in the late thirties.

The Matador cigarettes carton was made in Germany in the twenties. Its beautifully balanced composition reveals its debt to Bauhaus aesthetics.

FILL 'ER UP

AUTOMOTIVE-CARE PRODUCTS

Before 1920, most automobile makers, like other manufacturers of consumer goods, stressed the superior qualities of their product over the style and appearance of its "packaging." But in the increasingly competitive automotive market of the late twenties, even old Henry Ford realized that mechanical dependability alone was not going to push the sales button on the cash register. Advertising began to abstract the automobile with layer upon layer of metaphors for speed, modernity, status, and even sex. Consumers began to pass up the black, boxy, no-frills Model T and cross the street to the Chevrolet sales lot, where a competitively priced "package deal" and more modern styling awaited them. Buying a car in the mid-thirties was like buying any other packaged consumer product—the use of the brand name replaced the thing itself. You didn't just buy a car, you bought a De Soto. ■ To the delight of the packaging industry, maintaining the automobile required a veritable army of products, all of which, in turn, needed a package. Motor oils and greases like Red Giant and Parapride were sold in tin cans. Then, as now, text on the cans emphasized the economy, purity, and laboratory testing of the product. ■ The early inflatable rubber tire had an inner tube that could be punctured easily. Many brands of tube-repair kits marketed in the thirties were sold in tubes themselves, ones made of tin or a less expensive combination of fiberboard and tin. The metal buffer lids were conveniently pierced like a vegetable grater so that they could function as a scraper to roughen the surface of the rubber before the patches were glued on. The package for the Camel tube patch, oddly enough, is almost identical in design to that of the cigarette brand of the same name. ■ The Pep Boys—Manny, Moe, and Jack—were once the real-life owners of an auto supply store in Philadelphia that opened in 1921. The use of novelty lettering, humorous cartoon characters, bright colors, and geometric forms on everything from cans for transmission grease to the Handy Bulb Kit tins was a free-wheeling interpretation of Modernist design. ■ Owning a car means occasionally washing and waxing it. For owners of new streamlined Hupmobiles and Airflows, plenty of products were available to do the job. The Plastone (plastic-tone) label from the mid-thirties illustrates a vehicle basking in the afterglow of a good rubdown. This car illustration graphically represents the new aerodynamic, inverted bathtubs that were cruising the new highways of America.

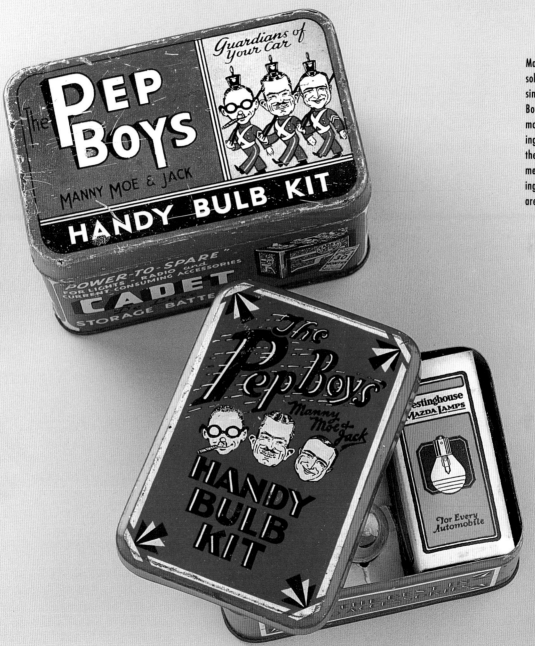

Manny, Moe, and Jack have sold quality merchandise since the twenties. The Pep Boys' lighthearted grease-monkey approach to marketing is a welcome relief from the predictable "macho-mechanic" style of advertising. The Handy Bulb Kit tins are from the thirties.

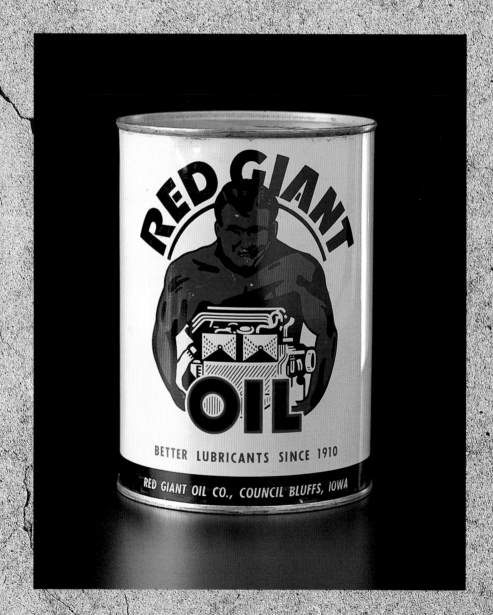

The archetypal symbol of thirties industrial America—the bare-chested, muscular male—conveys the endurance and dependability of Red Giant oil.

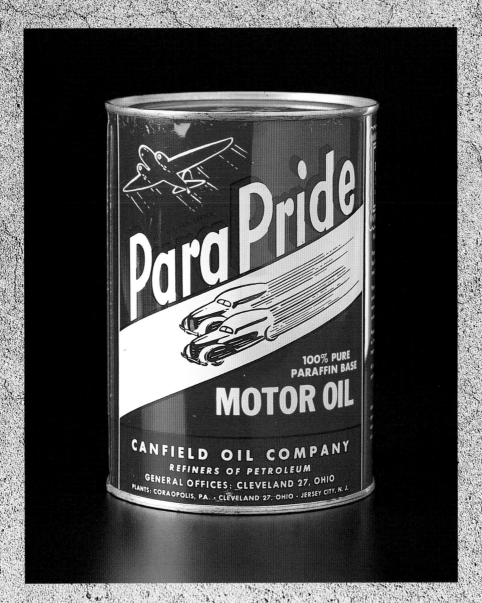

Canfield Oil Company refined the motor oil Parapride in the late thirties.

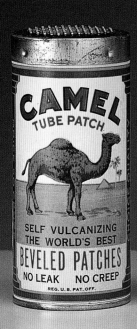

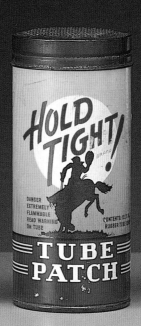

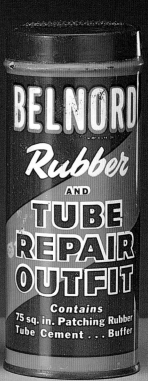

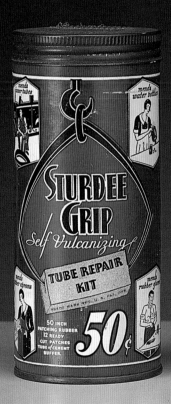

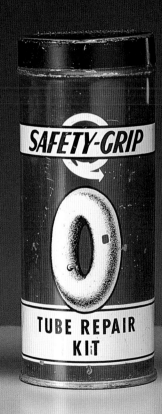

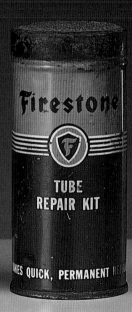

Customers discovered that tube repair kits were good for more than patching auto-tire punctures; they also came in handy for repairing such rubber items as boots, hot-water bottles, and gloves. Starting with descriptive names like Hold Tight! and Sturdee Grip, commercial artists of the thirties came up with inventive, illustrative solutions to packaging.

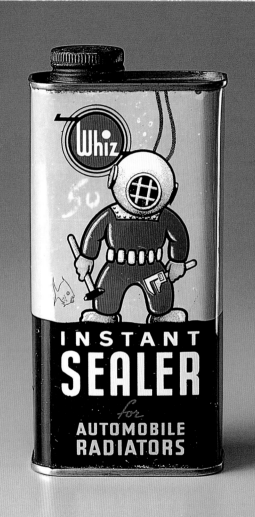

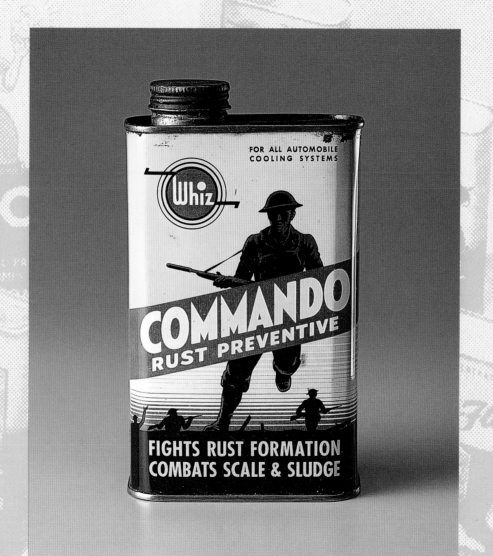

R. M. Hollingshead Corporation, with headquarters in the United States and Canada, produced Whiz auto-maintenance products. The company was internationally known for its unconventional packaging graphics. These tins, produced around 1938, have directions printed in English, Spanish, and French.

The repeated image of an auto being "rubbed down" forms the background pattern on the Varsity Cleaner tin of 1933. The type treatment and graphics mirror the decade's aesthetic sensibilities.

T. M. REG. U. S. PAT. OFF.

VARSITY

NEW
IMPROVED
CLEANER

A PRODUCT FOR EVERY CAR NEED

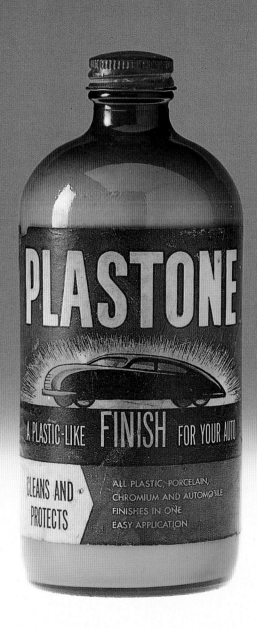

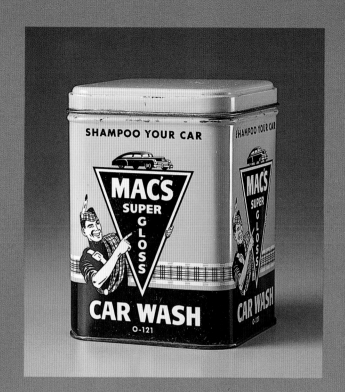

The label for Plastone boasts that the product was "scientifically compounded and laboratory checked" to ensure quality. Like today's auto cleaner and polish labels, Plastone promised "quick, super-easy application." The air-flow design of the car illustration dates this package, c. 1934.

Mac's Super Gloss car-wash tin borrows the stereotyped image of the thrifty Scotsman to sell the powdered product, c. 1940.

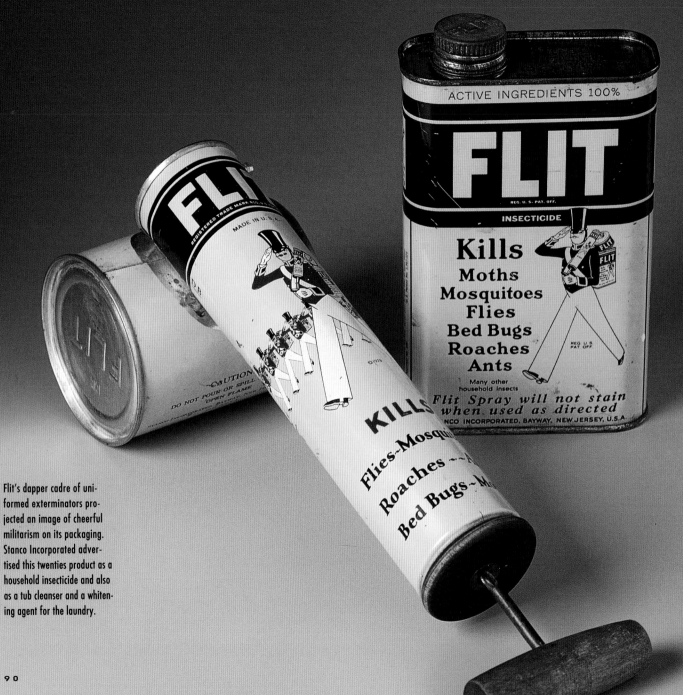

Flit's dapper cadre of uniformed exterminators projected an image of cheerful militarism on its packaging. Stanco Incorporated advertised this twenties product as a household insecticide and also as a tub cleanser and a whitening agent for the laundry.

H O M E / W O R K

HOME AND OFFICE PRODUCTS

The new American symbols of urbanism and modernity—skyscrapers, bridges, trains, automobiles, ships, airplanes, and factories—were liberally applied to all sorts of product packaging for home and business use. ▣ The front and back panels of the Empire State assorted-needle kit, a somewhat sedate and matronly product, depict images of frantic city life. The colorful illustrations, in slightly off-kilter perspective, are crowded with office towers, boats, and even a dirigible. A skywriting plane has spelled out the product's name on either side of a towering structure reminiscent of the Empire State Building. This particular kit was designed and printed in Japan, which may account for the curious red flags waving atop an otherwise distinctly American metropolis. ▣ The Windsor Broom Company label, with its speeding race car, is an attractive, highly stylized design in white, yellow, red, and black. This diminutive graphic (three and a half by six inches) has all the presence and eye-stopping power of a Modernist European poster. During the thirties and forties, American commercial artists got a firsthand look at the work of many of Europe's leading artists. Fleeing fascism, such masters of poster design as A. M. Cassandre, Jean Carlu, and Joseph Binder eventually settled in the United States. These and other émigrés from the Continent brought a new substance to American modern design that was highly stylish and intelligent. ▣ As ominous storm clouds formed over most of the industrialized world in the late thirties, other symbols of Modernism made themselves known. Packaged goods graphically evoked the controlling State and its accompanying patriotic militarism in every fascist, socialist, and even democratic country. The imagery and icons of the war machine had many incarnations, too—some benign, some subtle, and some blatant. ▣ Flit bug killer's friendly spraygun-carrying soldier is an intentionally humorous image. Its tin is printed in yellow and black—signature colors for insecticide products. ▣ The Kochs Adler Nähmaschinen tin in gold and reddish brown has the handsome yet sinister graphic of an eagle looming over a sewing machine. It subliminally and effectively communicates the message of German superiority and power. ▣ The Cadie polishing cloth box with its saluting servicemen is typical of the American packaging design of the forties that used a military theme. It lacks the abstract and stylized quality of its European counterparts. Such bald patriotism has often been a popular—if unimaginative—marketing tool for selling to the American public.

Towering skyscrapers and machine-age transportation are celebrated images on both sides of the Japanese-made Empire State Needle Assortment Kit, c. 1933.

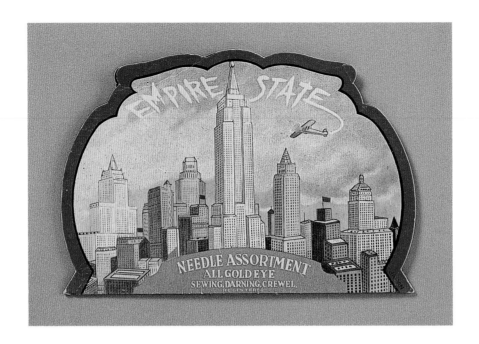

The striking illustration on Kochs Adler Nähmaschinen tin reflects the thirties taste for German graphic design founded in images charged with power and nationalism.

A stylized drop of oil with wings symbolizes McNess' Household Machine Oil's quick-lubricating properties, c. 1936.

The Windsor Broom Company of Hamburg, Pennsylvania, commissioned the posterlike label design for Auto No. 6 in the early thirties. The stylized racing car, airbrushed speedlines, and period lettering would have added an exciting Modernist flair to any broom handle.

Maguey derives its product name and visual theme from the agave, or century plant, native to the American southwest. It is one example of the high aesthetics devoted to packaging for cleansers, polishes, and other utilitarian products in the thirties.

Designed by William O'Neil in 1935, Boraxo's wide black-and-white bands, red cap, and red product lettering lend themselves to strong shelf visibility. The famous twenty-mule team pulls borax-filled wagons under the Death Valley sun.

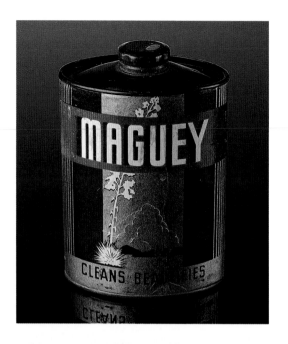

French commercial artists used popular symbols of black culture, both African and Jazz-Age American, on posters, character marks, and advertising. Uireffet, the comical if stereotypical mascot created by Georges Favre for Berger-Grillon, carries oversized containers of the company's household products. The easel-backed counter display was printed in Paris in 1932.

The image of a cheery canary fits well with the upbeat product name—Sing's. The Hood Chemical Company of New York fledged the general household cleaner in the mid-forties.

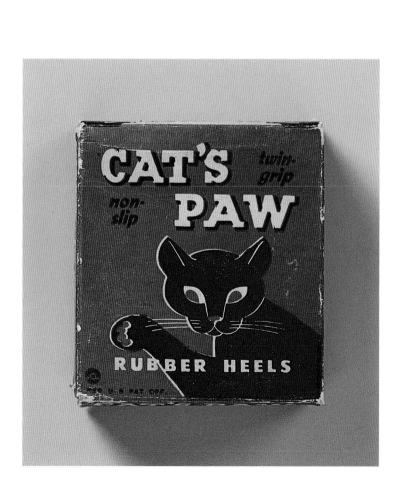

Using a parrot's image for a product called Polyshine may seem corny by today's standards, but in Depression Era America naive name associations and guileless humor often won out over more sophisticated solutions. The shoe polish was manufactured in Rochester, New York, c. 1935.

Lucian Bernhard designed the character mark for Cat's Paw Rubber Company of Baltimore in 1941. The folding carton, which held rubber heels, dates from a few years later.

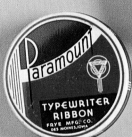
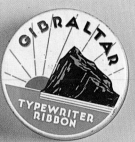

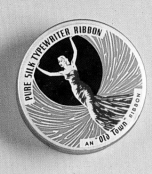

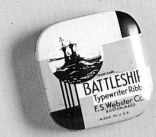

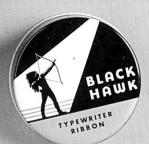

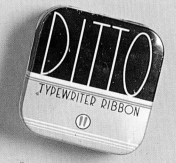

An almost extinct species today, typewriter ribbons were once a common item in any office supply's inventory. They were manufactured from closely woven fabrics such as cotton or nylon or the *ne plus ultra* of cleanly struck, smudge-free typing— silk. Averaging only two and a half inches across, the ribbon tins on these two pages date from the early twenties (Paramount) to the mid-forties (Battleship). The ingenious assortment of typographic and pictorial themes that enliven this product's containers is a testimonial to Modernism's attempt to imbue the packaging of even the most pedestrian manufactured goods with a strong, often elegant, selling personality. Wrapped in cellophane, the spool-wound ribbon remained fresh for years in its tight-fitting, friction-lidded tin.

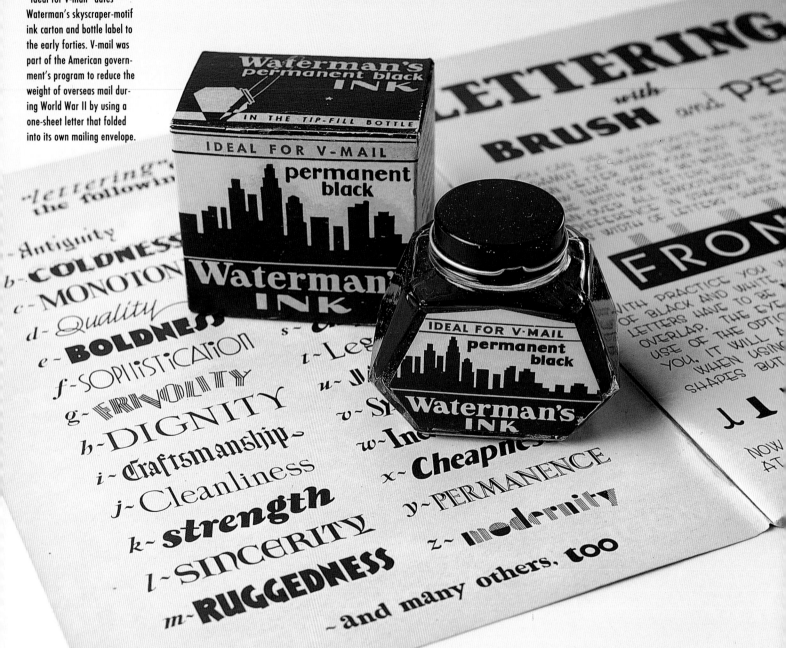

"Ideal for V-mail" dates Waterman's skyscraper-motif ink carton and bottle label to the early forties. V-mail was part of the American government's program to reduce the weight of overseas mail during World War II by using a one-sheet letter that folded into its own mailing envelope.

The companies that packaged Cadie polishing cloth and Ol' Sarge gun oil capitalized on America's patriotic zeitgeist during World War II in marketing their products. The graphics on the Cadie's carton are an example of the unchallenged racist images that proliferated in packaging and advertising of the time.

Both sides of Dart and Household nail tins were lavished with Modernist decoration.

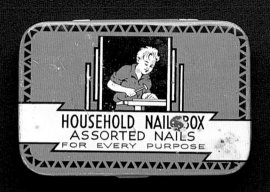

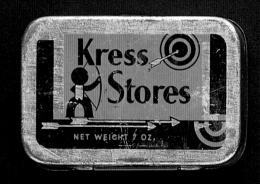

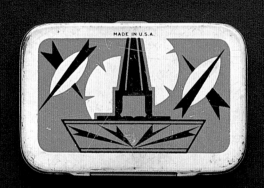

A. A. Vantine and Company, headquartered on New York's posh Fifth Avenue in the thirties, sold incense in cone, cake, rod, and powdered form. The line was packaged in glamourous tins of unusual shapes and sizes. The back panel text read like an ad for an opiated elixir: "With its sweet breath vanishes all suggestion of the work-a-day world with its odors, its hustle, its cares."

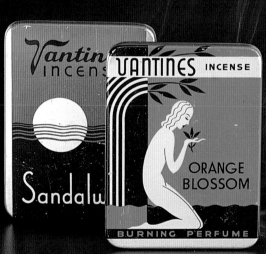
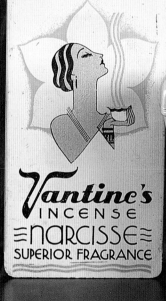
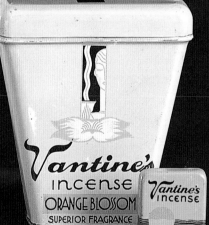

PLAYING AROUND

GAMES, PUZZLES, AND ART SUPPLIES

If the number of board and card games, puzzles, and stamp and art kits found at today's flea markets and antique stores are any indication of what the twenties, thirties, and forties were about, a lot of playing around took place that was both creative and socially inspired. Television, after all, would not make any real inroads into American leisure until the fifties. With few exceptions, most games and puzzles were packaged in rigid set-up boxes made of inexpensive chipboard and covered with brightly printed paper wrappers. Saturated reds, oranges, yellows, blues, and black were the most prominent colors used for such packaged entertainment. Products used exclusively by adults, however, were comparatively restrained. The packaging for Reeves pastels and Eagle's Mikado drawing pencils both employ the dramatic color combination of red and black but retain a classical "feel," with their stiff, stylized animals and elegantly proportioned typefaces. Tiddledy Winks and Cords and Knots game boxes, obviously marketed for children, are loud and full of action, using Jazz Age concentric circles and diagonals to draw attention and stimulate excitement. ▪ Then, as now,

the box lid was sometimes nothing but a disappointing oversell. The cover of the 'Prentice set of rubber stamps suggests to any neophyte typesetter that his introduction to grandpa's midtown office was lying somewhere within. But after shelling out fifty-nine cents, the Depression Era kid would take his purchase home to discover a scant assortment of minuscule letters with cheap wooden accessories—a thirties-style rip-off. ▪ The Tek-No-Krazy box lid is illustrated with two happy robots, complete with spark plugs, dials, and antennas, absorbed in the game. But when the lid is removed, the connection with the wacky robots is lost. What is revealed is a simple wooden playing board with metal pegs—bereft of any state-of-the-art Machine Age technology. ▪ Frequent graphic redesign on game packaging was not unusual. Originally packaged with streamlined images of white silhouetted acrobats, the game of Alee-Oop was launched by the Roy-Toy Company in the early thirties. By 1937 the container was redesigned by the (renamed) Royal Toy Company with scenes of cavemen and dinosaurs derived from the comic strip. Thus, in the thirties' poker game of packaging redesign and marketing, the geometric men were sometimes dealt the losing hand against the troglodytes.

Mickey Mouse takes center stage, flanked by multicolored raybands, on the Cine Art Films carton. Film and container were made by Walt Disney Productions in Hollywood, California, c. 1930.

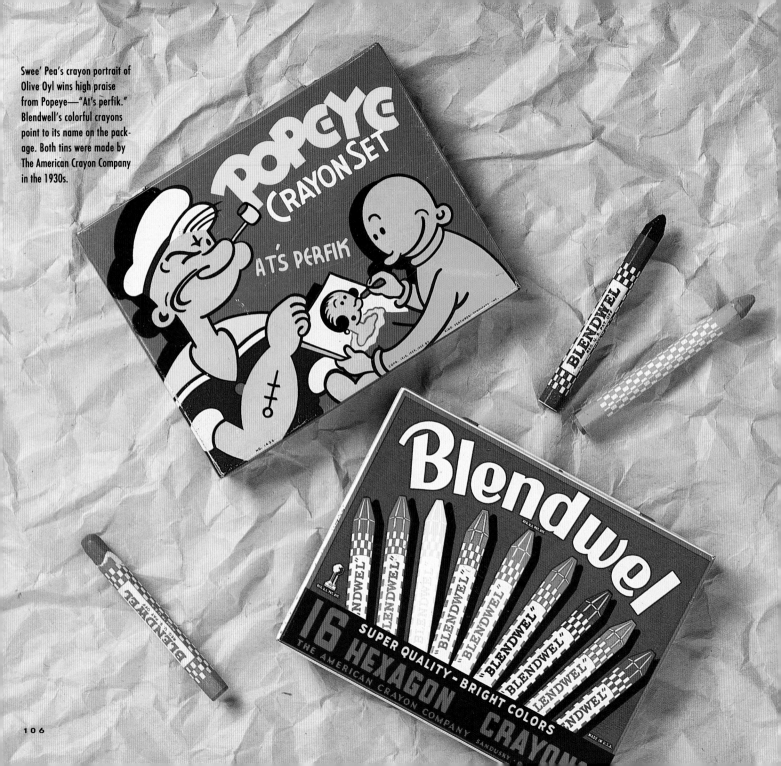

Swee' Pea's crayon portrait of Olive Oyl wins high praise from Popeye—"At's perfik." Blendwell's colorful crayons point to its name on the package. Both tins were made by The American Crayon Company in the 1930s.

The box for 'Prentice Rubber Type Set, c. 1930, promised more than the package actually contained.

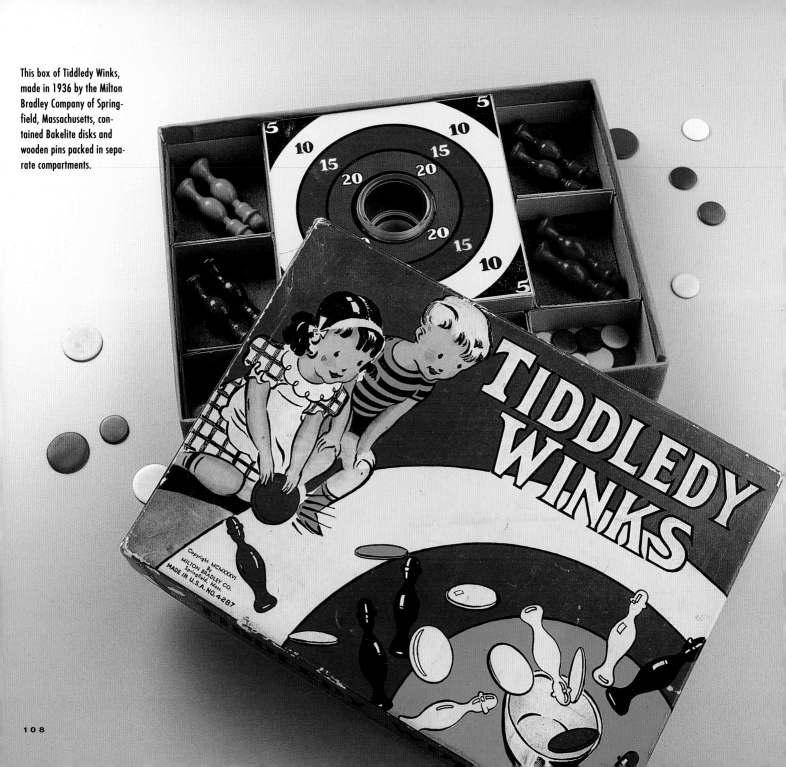

This box of Tiddledy Winks, made in 1936 by the Milton Bradley Company of Springfield, Massachusetts, contained Bakelite disks and wooden pins packed in separate compartments.

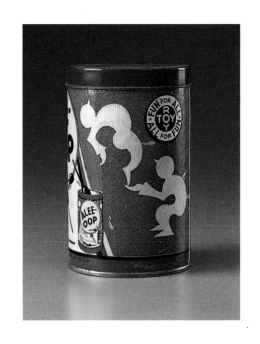

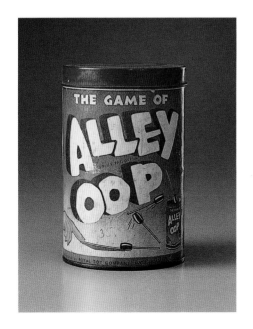

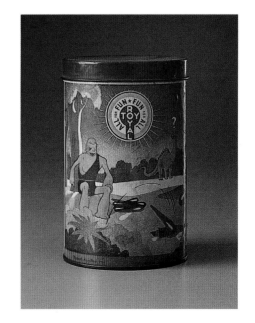

The game Alee-Oop was released in the thirties by the Roy-Toy company, perhaps capitalizing on V. T. Hamlin's comic-strip character. In 1937 the correct spelling for the comic caveman along with his prehistoric stomping grounds were assimilated into the package design by the (renamed) Royal Toy Company.

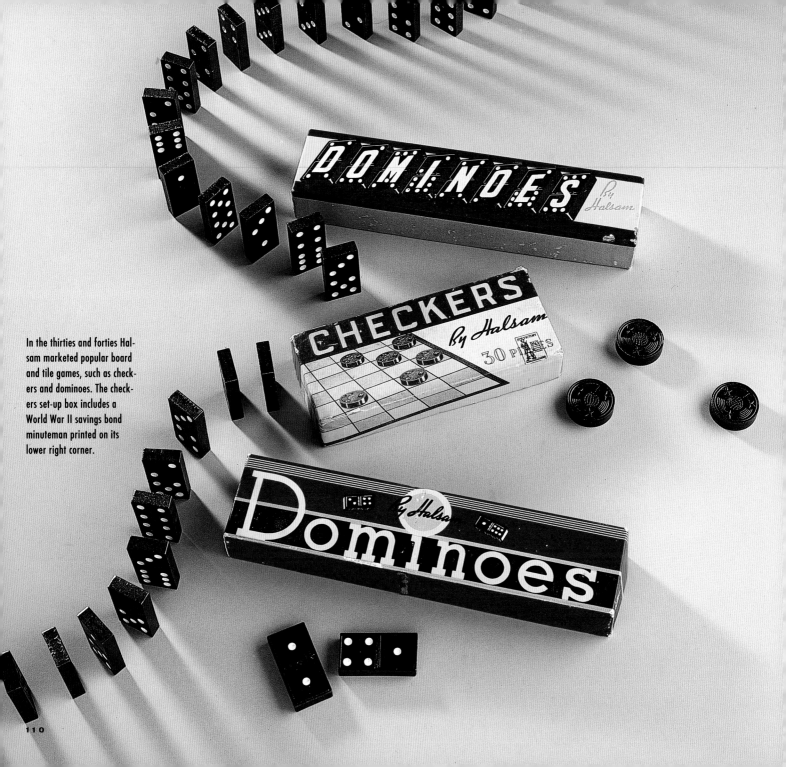

In the thirties and forties Halsam marketed popular board and tile games, such as checkers and dominoes. The checkers set-up box includes a World War II savings bond minuteman printed on its lower right corner.

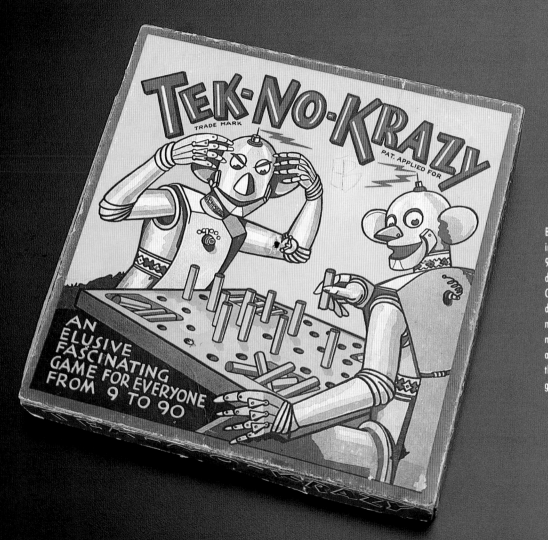

Billed as "an elusive fascinating game for everyone from 9 to 90," Tek-No-Krazy was distributed by Reilly and Lee Company of Chicago. The dueling robot illustration says more about the machine-crazy mood of the thirties than about the actual workings of this decidedly low-tech board game.

The Toy Tinkers, Inc. of Evanston, Illinois, sold Tinkersand Pictures in the thirties along with its better-known product, Tinker Toy.

The Transogram Company of New York offered the Cords and Knots activity game to the public in 1938. Graphics touted the thrill of tying timber hitch knots and knitting "horse reins."

OUTLINE CARDS AND ALL MATERIALS FOR MAKING LASTING AND DECORATIVE PICTURES IN COLORED SAND

TINKERSAND PICTURES

AN ART EASY TO LEARN PRODUCED BY THE TOY TINKERS INC. EVANSTON, ILLINOIS MADE IN U.S.A.

"GOLD MEDAL" REG. U.S. PAT. OFF.

NEW TWISTS TO CORDS AND KNOTS

No. 3558 © 1938 BY TRANSOGRAM COMPANY, INC., N. Y.

The packaging for Megow's Precision Planned Flying Models is economically printed in two colors on chipboard, one of the lowest grades of paperboard. However, the strong graphics of the piece are not compromised by this limitation, c. 1935.

Saleable Products Company of Los Angeles manufactured the Good Luck railroad game in the thirties.

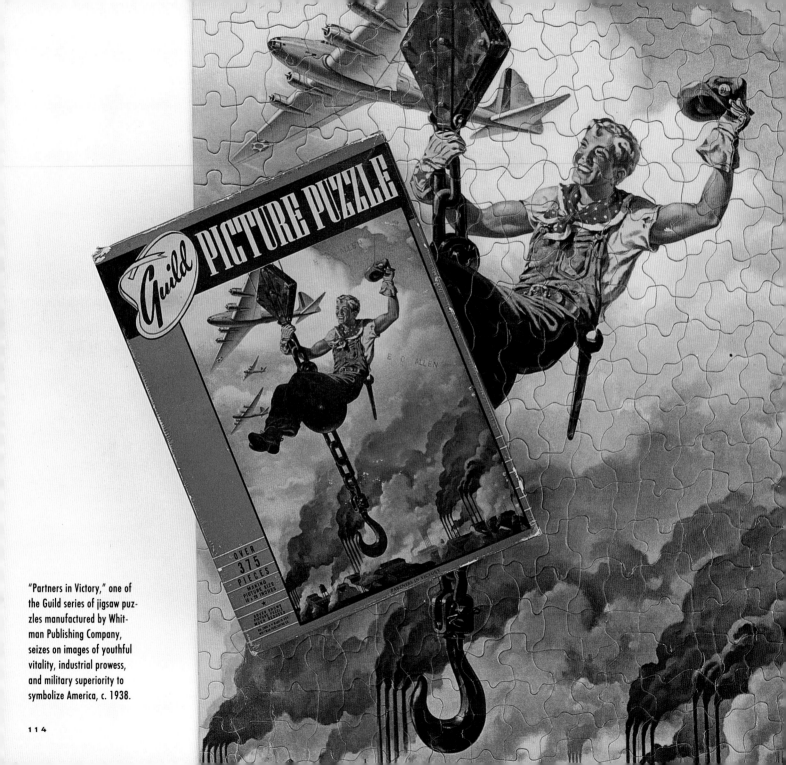

"Partners in Victory," one of the Guild series of jigsaw puzzles manufactured by Whitman Publishing Company, seizes on images of youthful vitality, industrial prowess, and military superiority to symbolize America, c. 1938.

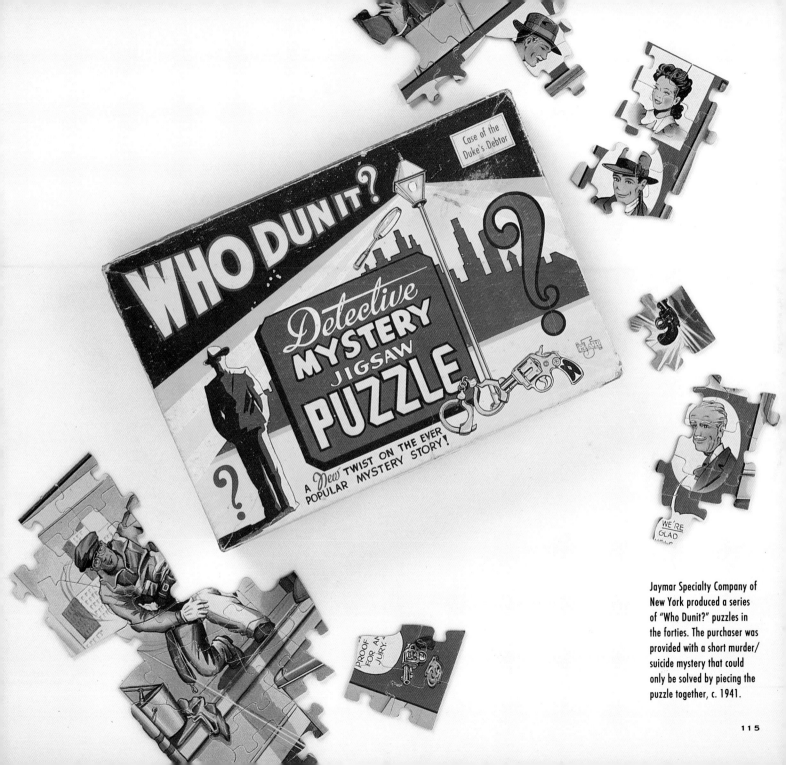

Jaymar Specialty Company of New York produced a series of "Who Dunit?" puzzles in the forties. The purchaser was provided with a short murder/suicide mystery that could only be solved by piecing the puzzle together, c. 1941.

Monopoly, the board game created by Charles Darrow, and Touring, a card game with an automotive theme, were both patented by Parker Brothers around 1935. Monopoly was licensed for overseas distribution and soon was all the rage in Great Britain and Australia.

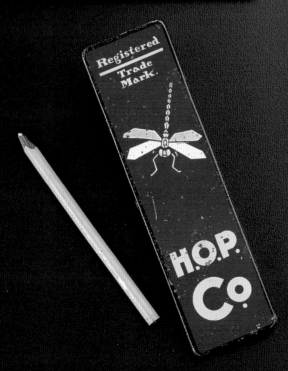

George Switzer designed the handsome packaging for Eagle Mikado-brand "Chemi-sealed" pencils in 1936. The stylized eagle trademark appears to have been inspired by the WPA bird.

The H.O.P. Company of Japan produced this elegant (and rare) little tin container for colored pencils. The use of negative space, asymmetrical layouts, and economic, stylized illustrations was a hallmark of Japanese graphics, c. 1920.

Reeves' "Greyhound" Pastels tin, with its tastefully rendered, polka-dotted dog, was a late-twenties British production.

BIBLIOGRAPHY

Atwan, Robert; McQuade, Donald; Wright, John W. *Edsels, Luckies, and Frigidaires.* New York: Dell Publishing Co., Inc.,1979.

Barail, Louis C. *Packaging Engineering.* New York: Reinhold Publishing Corporation, 1954.

Battersby, Martin. *The Decorative Twenties.* New York: Walker and Co.,1969.

_____. *The Decorative Thirties.* New York: Walker and Co.,1971.

Boorstin, Daniel. *The Americans—The Democratic Experience.* New York: Random House, 1973.

Birren, Faber. *Color in Modern Packaging.* Chicago: The Crimson Press, 1935.

Commercial Art and Industry. "New Packs for Old Products." London: The Studio Ltd. Vol. XVIII. No. 103. January 1935, pp.1–7.

Davis, Alec. *Package and Print—The Development of Container and Label Design.* New York: Clarkson N. Potter, Inc., 1967.

Duncan, Alastair. *American Art Deco.* New York: Harry N. Abrams, 1986.

Fortune Magazine. "New Packages." New York: Time Inc. Vol. III. No.5. May 1931, pp. 76–79.

Franken, Richard B. and Larrabee, Carroll B. *Packages That Sell.* New York: Harper and Brothers Publishers, 1928.

Gray, Milner. *Package Design.* London: The Studio Publications, 1955.

Grief, Martin. *Depression Modern: The Thirties Style in America.* New York: Universe Books, 1975.

Hillier, Bevis. *Art Deco.* New York: E. P. Dutton, 1968.

Humbert, Claude. *Label Design.* New York: Watson-Guptill Publications, 1972.

Johnson, Laurence A. *Over the Counter and on the Shelf.* Rutland, Vermont: Charles E. Tuttle Company, 1961.

Kery, Patricia Frantz. *Art Deco Graphics.* New York: Harry N. Abrams, 1986.

Kimura, Katsu. *Art Deco Package Collection.* Japan: Rikyu-sha, 1985.

Meggs, Phillip B. "The Women Who Saved New York!" *Print.* Bethesda, Maryland: R. C. Publications, Inc. Vol. XLIII. No. 1. January/February 1989, pp.61–71, 162–164.

Miller, J. Abbott. "The 1980s: Postmodern, Postmerger, Postscript." *Print.* Bethesda, Maryland: R. C. Publications, Inc. Vol. XLIII. No.6. November/December 1989, pp.162–185, 202–208.

Morgan, Hal. *Symbols of America.* New York: Penguin Books, 1987.

Neubauer, Robert G. *Packaging, The Contemporary Media.* New York: Van Nostrand Reinhold Company, 1973.

Pilgrim, Dianne H.; Tashjian, Dickran; Wilson, Richard Guy. *The Machine Age in America 1918–1941.* New York: Brooklyn Museum and Harry N. Abrams, 1986.

Packaging Catalog 1937. New York: Breskin and Charlton Publishing Corporation, 1937.

Rice, James O. *Packaging, Packing and Printing.* New York: Elliot Publishing Co., 1936.

Sacharow, Stanley. *The Package as a Marketing Tool.* Radnor, Pennsylvania: Chilton Book Company, 1982.

The 68th Art Directors Annual. "Raymond Loewy." New York: A D C Publications Inc.,1989.

Wright, Richardson. "The Modernist Taste." *House and Garden.* Greenwich, Connecticut: The Condé Nast Publications, Inc. Vol. XLVIII. No. 4. October 1925, pp. 77–79, 110, 114.